Coloring DC

THE FLASH™
AN ADULT COLORING BOOK

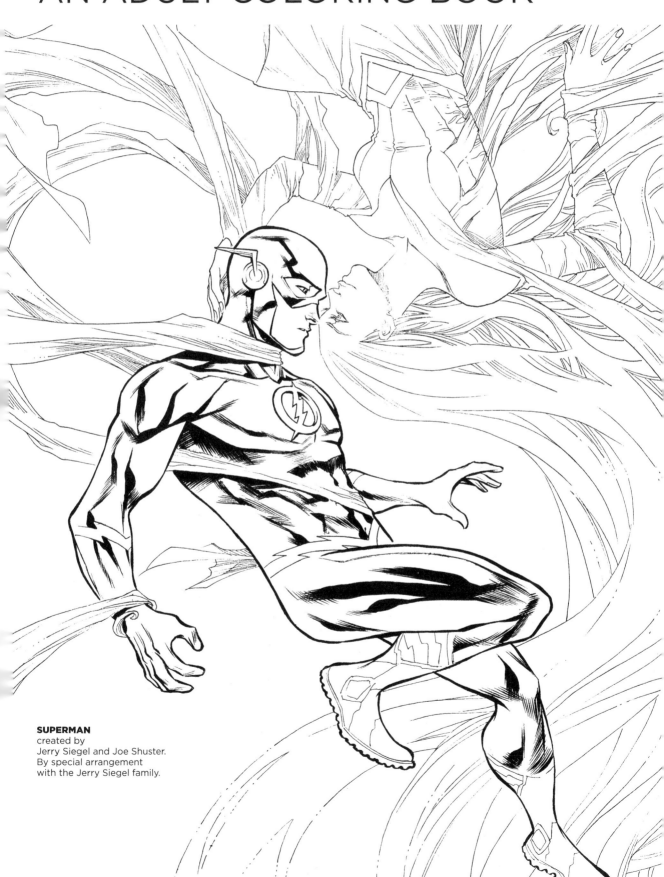

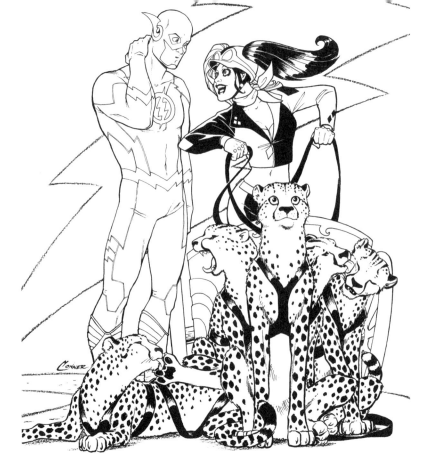

Editors –
Original Series
Brian Augustyn
Mike W. Barr
Eddie Berganza
Mike Carlin
Joey Cavalieri
Mark Chiarello
Mike Cotton
Brian Cunningham
Mark Doyle
Whitney Ellsworth
Mike Gold
Joan Hilty
Matt Idelson
Marie Javins
Barbara Kesel
Sheldon Mayer
Wil Moss
Dan Raspler
Julius Schwartz
Michael Siglain
Peter J. Tomasi
Stephen Wacker
Mort Weisinger

Associate Editors –
Original Series
Chris Conroy
Ruben Diaz
Rachel Gluckstern
Rex Ogle
Rickey Purdin
Harvey Richards
Adam Schlagman

Assistant Editors –
Original Series
E. Nelson Bridwell
Valerie D'Orazio
Kate Durré
Brittany Holzherr
Matt Humphreys
Alisande Morales
Darren Shan
Dan Thorsland
Amedeo Turturro
L.A. Williams
Michael Wright

Jeb Woodard — Group Editor – Collected Editions
Robin Wildman — Editor – Collected Edition
Steve Cook — Design Director – Books & Publication Design

Bob Harras — Senior VP – Editor-in-Chief, DC Comics

Diane Nelson — President
Dan DiDio and Jim Lee — Co-Publishers
Geoff Johns — Chief Creative Officer
Amit Desai — Senior VP – Marketing & Global Franchise Management
Nairi Gardiner — Senior VP – Finance
Sam Ades — VP – Digital Marketing
Bobbie Chase — VP – Talent Development
Mark Chiarello — Senior VP – Art, Design & Collected Editions
John Cunningham — VP – Content Strategy
Anne DePies — VP – Strategy Planning & Reporting
Don Falletti — VP – Manufacturing Operations
Lawrence Ganem — VP – Editorial Administration & Talent Relations
Alison Gill — Senior VP – Manufacturing & Operations
Hank Kanalz — Senior VP – Editorial Strategy & Administration
Jay Kogan — VP – Legal Affairs
Derek Maddalena — Senior VP – Sales & Business Development
Jack Mahan — VP – Business Affairs
Dan Miron — Vp – Sales Planning & Trade Development
Nick Napolitano — VP – Manufacturing Administration
Carol Roeder — VP – Marketing
Eddie Scannell — VP – Mass Account & Digital Sales
Courtney Simmons — Senior VP – Publicity & Communications
Jim (Ski) Sokolowski — VP – Comic Book Specialty & Newsstand Sales
Sandy Yi — Senior VP – Global Franchise Management

THE FLASH: AN ADULT COLORING BOOK

Published by DC Comics. Compilation and all new material Copyright © 2016 DC Comics. All Rights Reserved. Originally published in single magazine form in FLASH COMICS 1, 10; COMIC CAVALCADE 2; ALL-STAR COMICS 4, 54; SHOWCASE 4, 14; THE FLASH (VOL. 1) 105, 106, 112, 114, 115, 121, 123, 133, 139, 143, 149, 174, 177, 200, 309, 324, 330; THE BRAVE AND THE BOLD 28; JUSTICE LEAGUE OF AMERICA 1, 9; SUPERMAN 220; WORLD'S FINEST 199; DC COMICS PRESENTS 38; FLASH (VOL. 2) 11, 19, 98, 161, 167, 169, 178, 184, 186, 200, 201, 208, 225, 237; THE FLASH SPECIAL 1; ADVENTURES OF SUPERMAN 475; THE FLASH AND GREEN LANTERN: THE BRAVE AND THE BOLD 1, 3; JUSTICE LEAGUE ADVENTURES 7; THE FLASH: TIME FLIES 1; DC: THE NEW FRONTIER 2, 6; THE FLASH: THE FASTEST MAN ALIVE 1, 12, 13; BLACKEST NIGHT 6; THE FLASH: REBIRTH (VOL. 1) 6; THE FLASH (VOL. 3) 1, 6; THE FLASH: SECRET FILES AND ORIGINS 1; BATMAN: THE BRAVE AND THE BOLD 15; FLASHPOINT 1, 5; THE FLASH (VOL. 4) 3, 4, 12, 23, 26, 30, 31, 35, 37, 39, 48; JUSTICE LEAGUE 11; JUSTICE LEAGUE UNITED 8; TEEN TITANS 6; CATWOMAN 38; BATMAN 38; GREEN LANTERN 38; CONVERGENCE: THE FLASH 1; THE FLASH: REBIRTH (VOL. 2) 1; Copyright © 1940, 1941, 1943, 1950, 1956, 1958, 1959, 1960, 1961, 1962, 1963, 1964, 1967, 1968, 1969, 1970, 1981, 1982, 1983, 1984, 1988, 1990, 1991, 1995, 1999, 2000, 2001, 2002, 2003, 2004, 2005, 2006, 2007, 2008, 2010, 2011, 2012, 2013, 2014, 2015, 2016 DC Comics. All Rights Reserved. All characters, their distinctive likenesses and related elements featured in this publication are trademarks of DC Comics. The stories, characters and incidents featured in this publication are entirely fictional. DC Comics does not read or accept unsolicited submissions of ideas, stories or artwork.

DC Comics, 2900 West Alameda Ave., Burbank, CA 91505
Printed by RR Donnelley, Willard, OH, USA. 9/2/16. First Printing.
ISBN: 978-1-4012-7006-3 Library of Congress Cataloging-in-Publication Data is available.

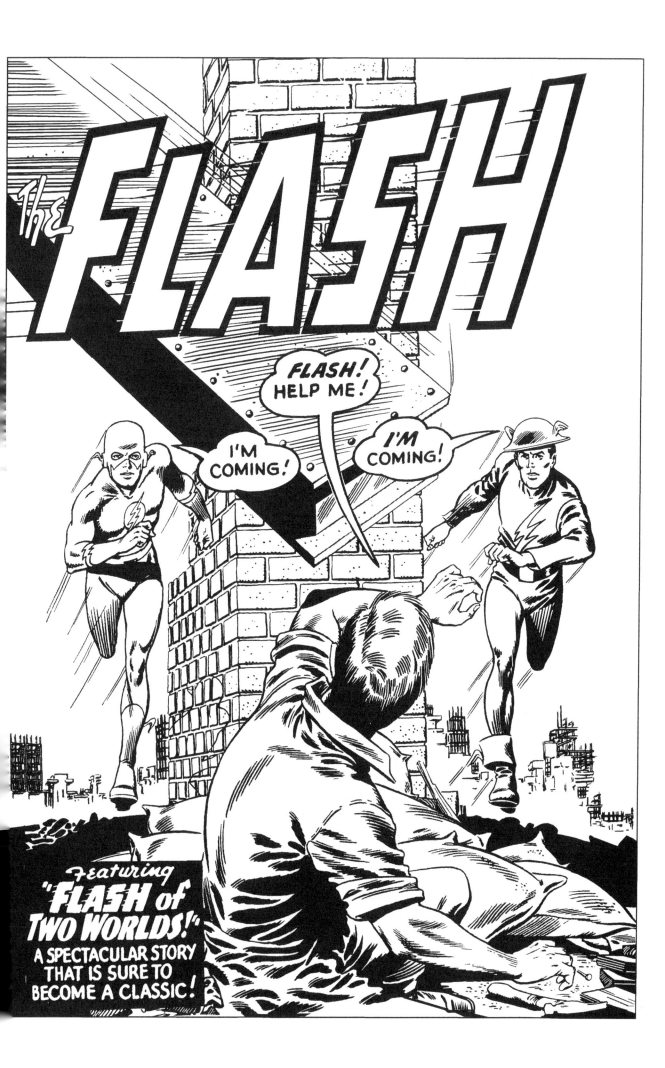

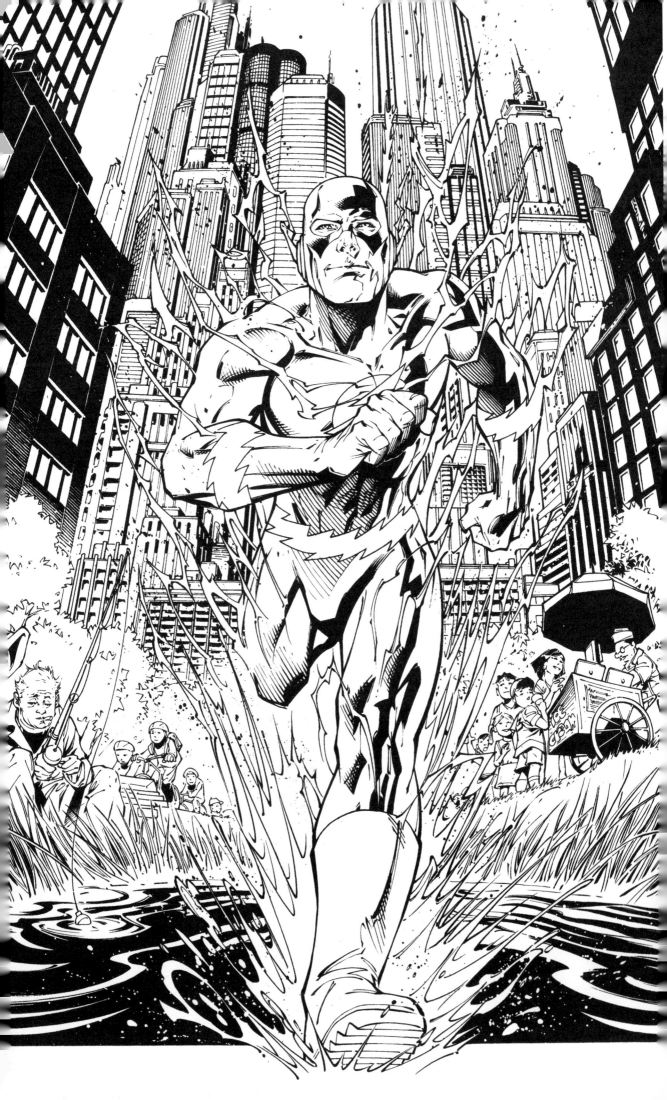

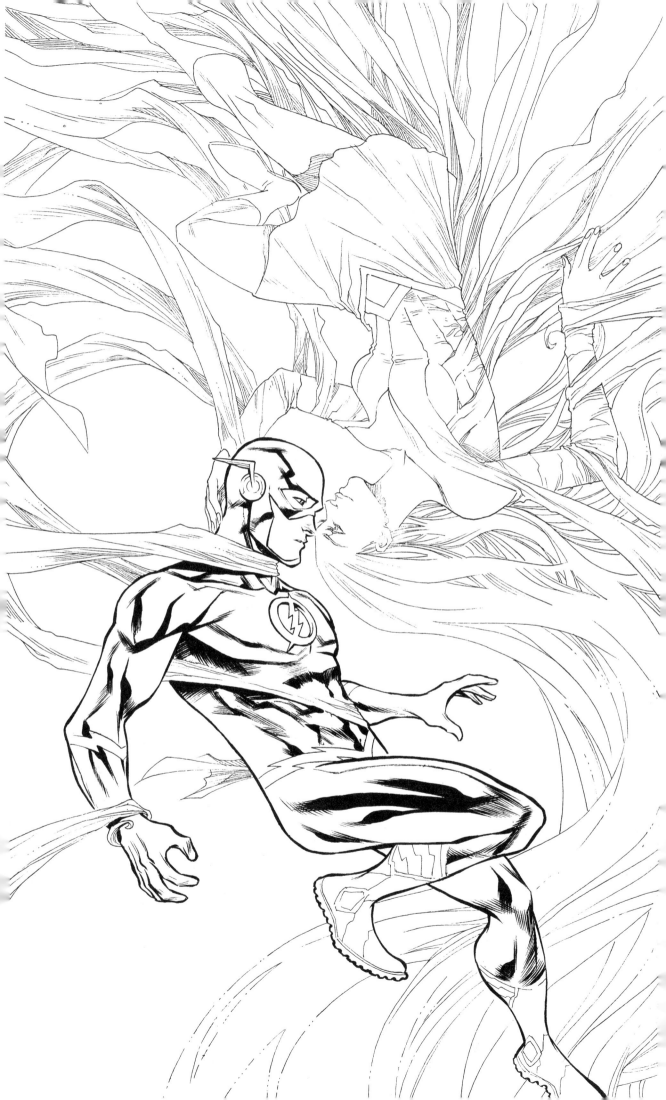

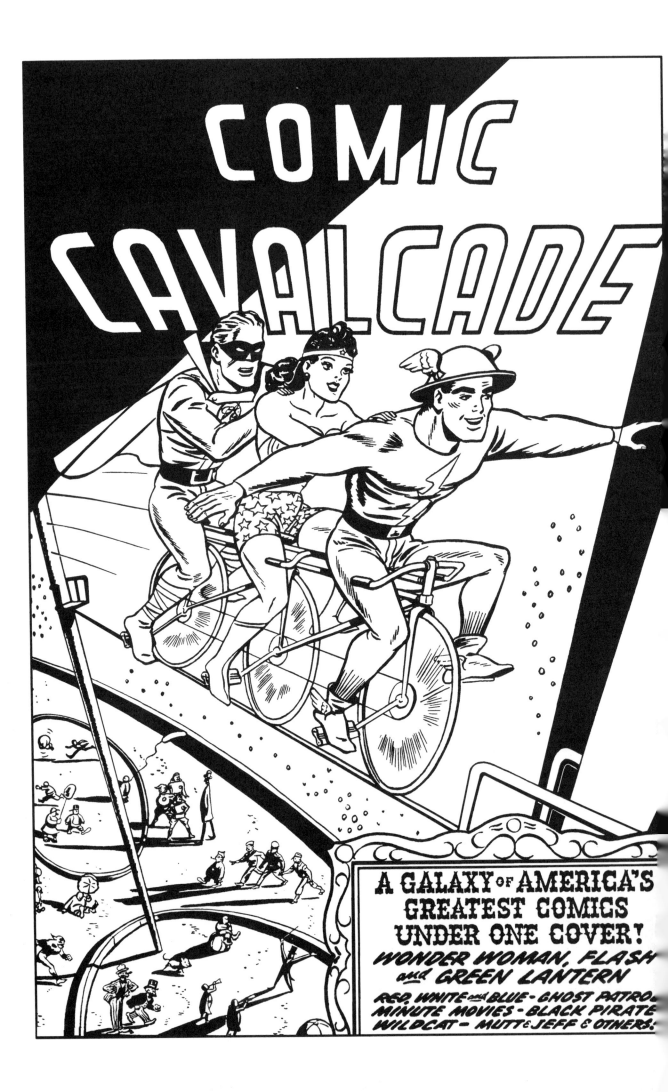

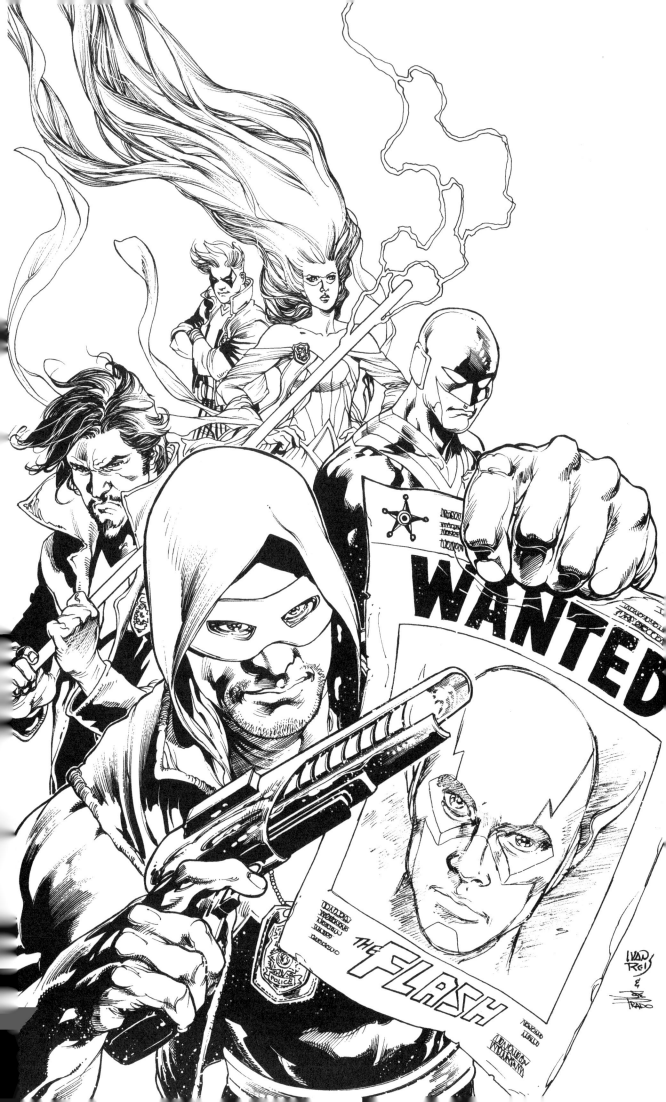

WANTED

THE FLASH

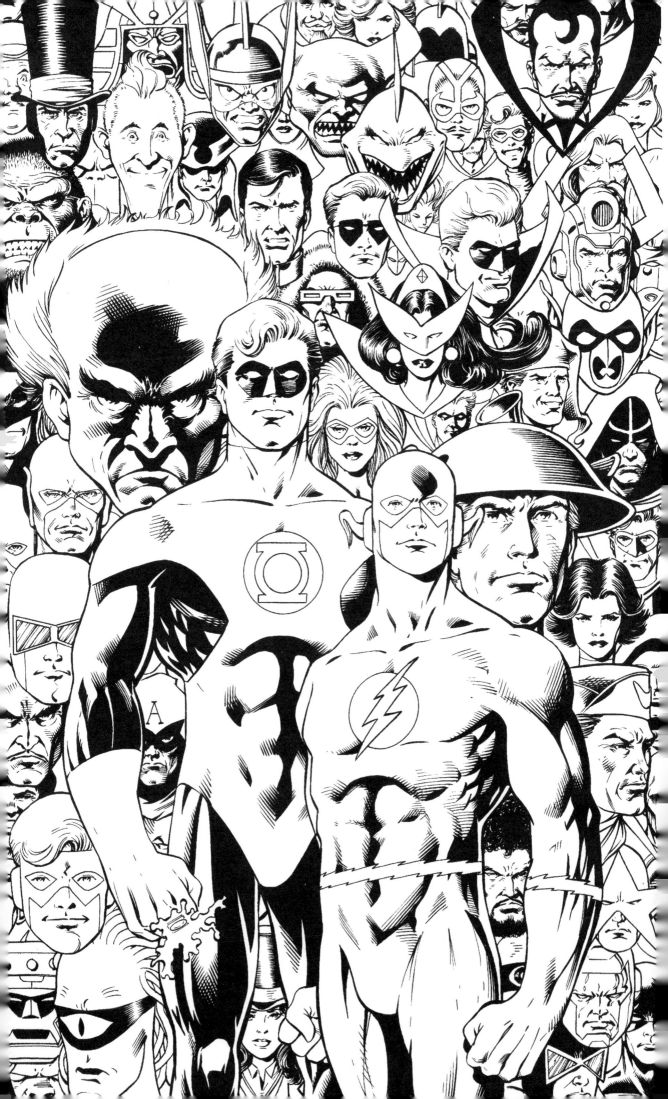

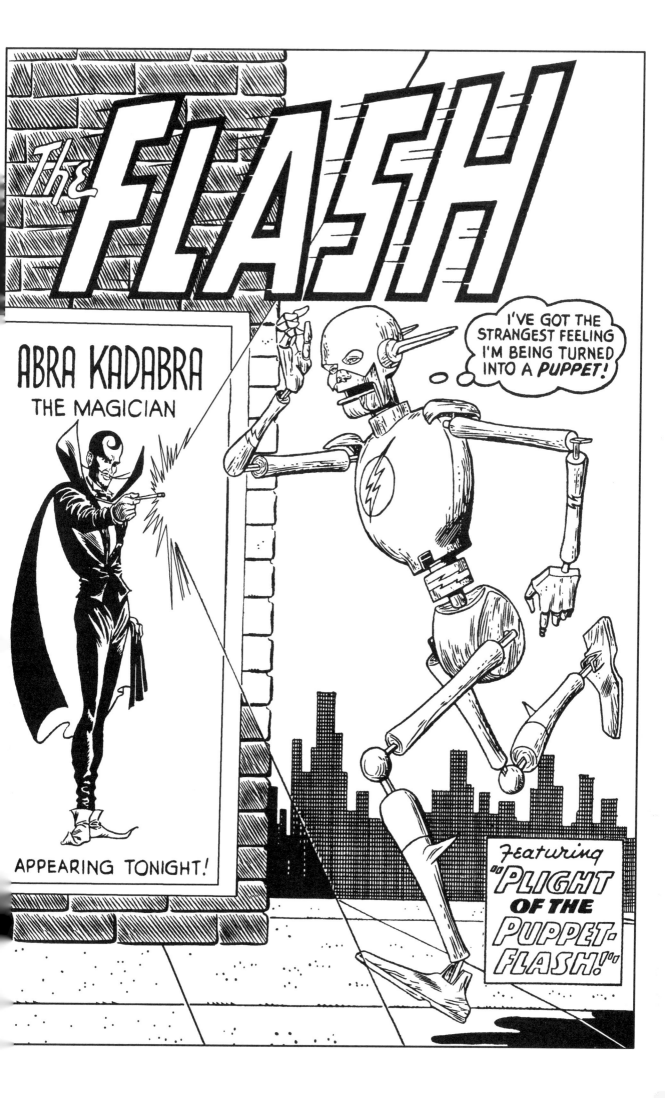

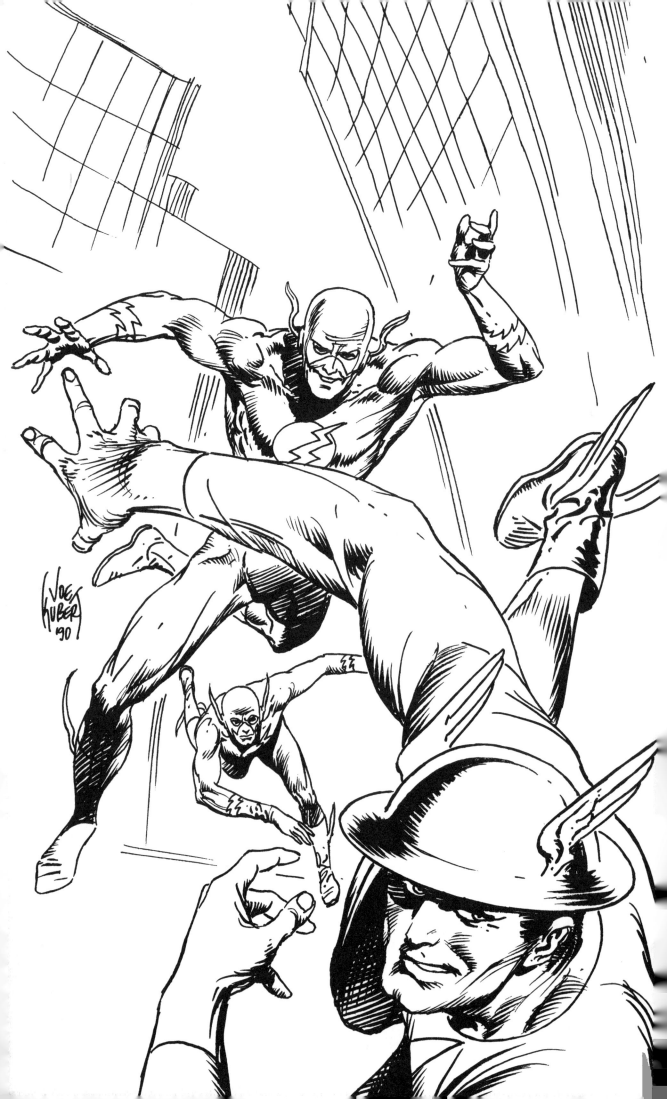

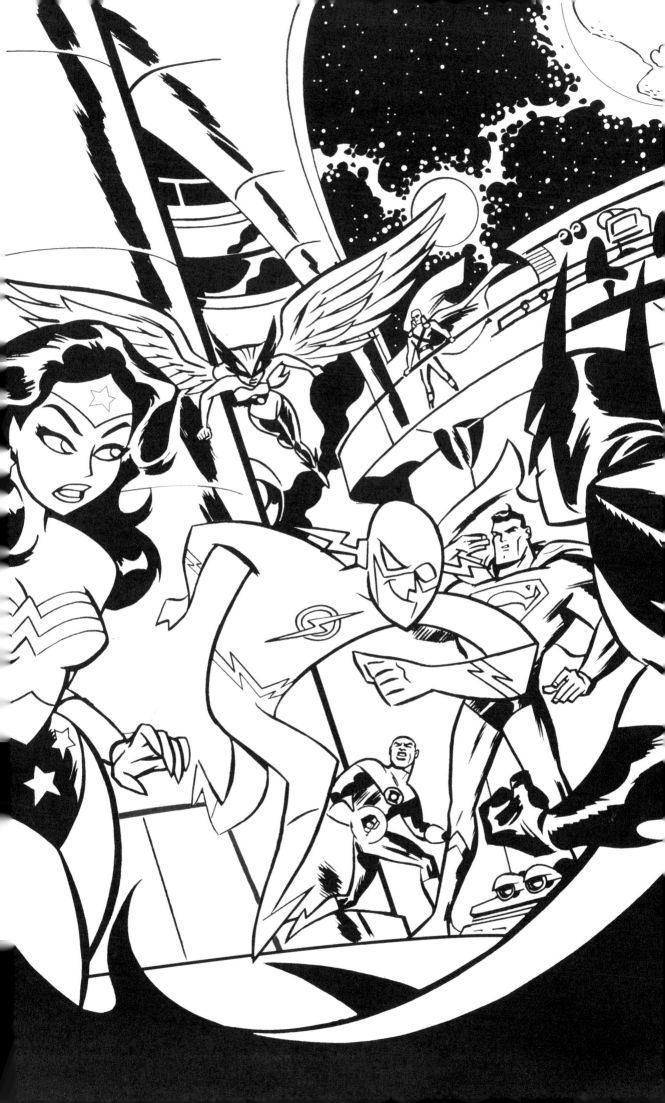

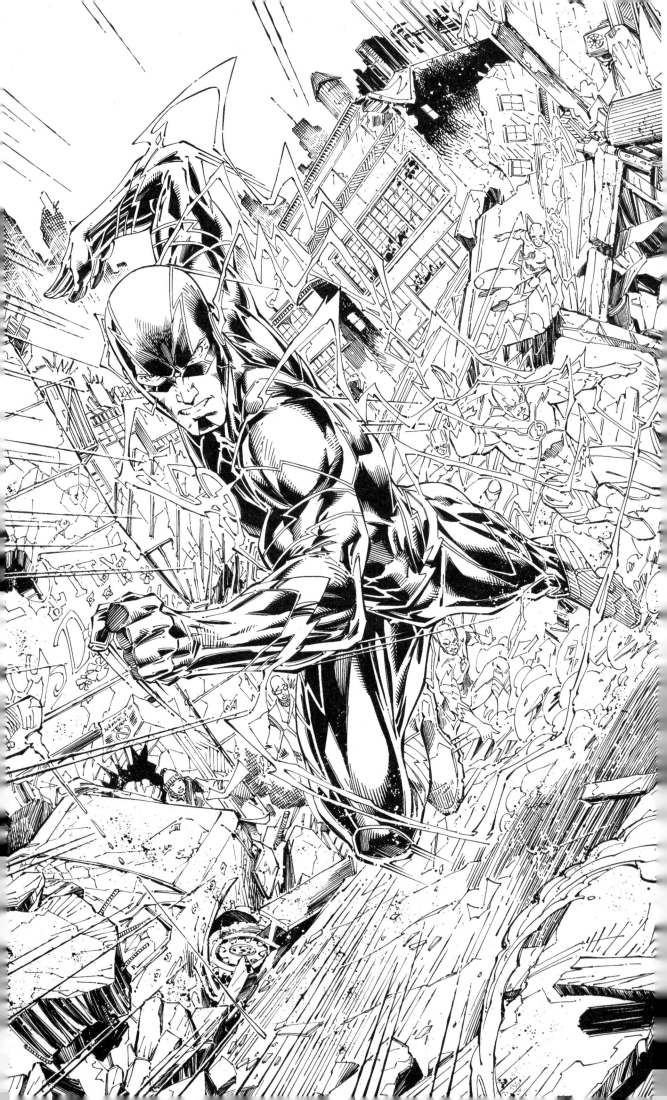

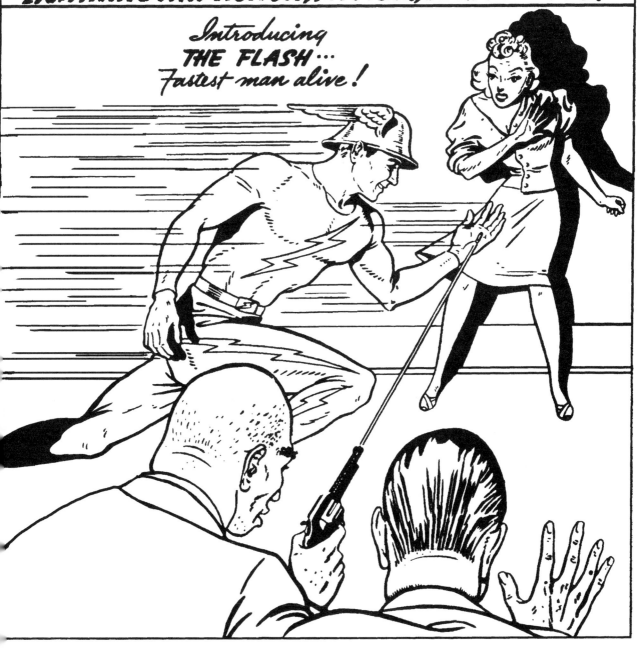

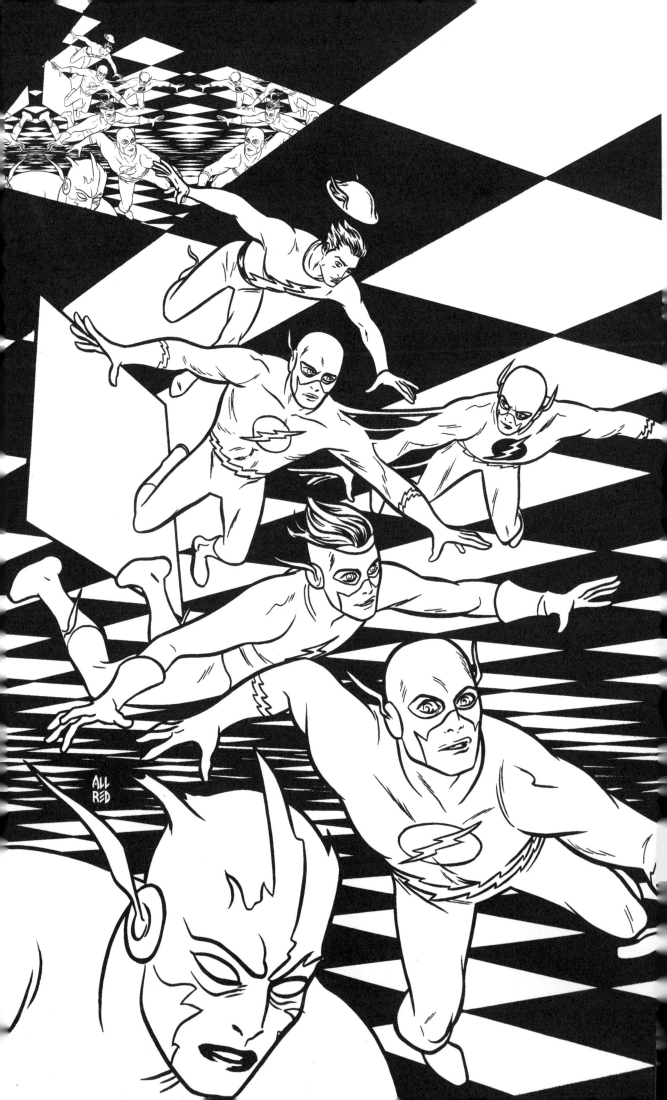

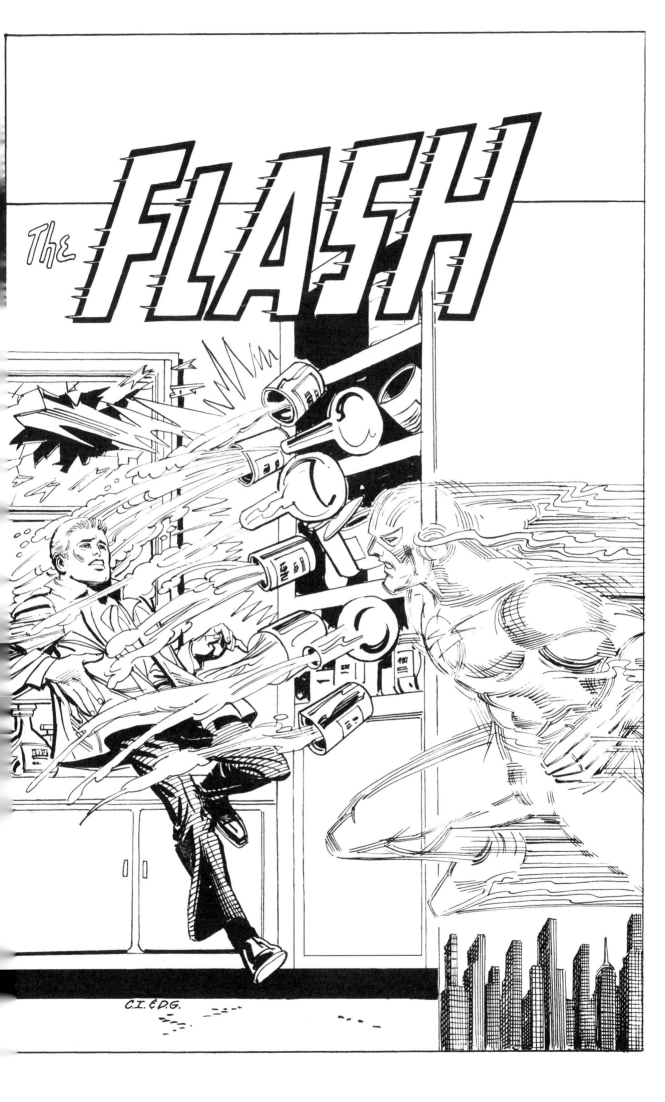

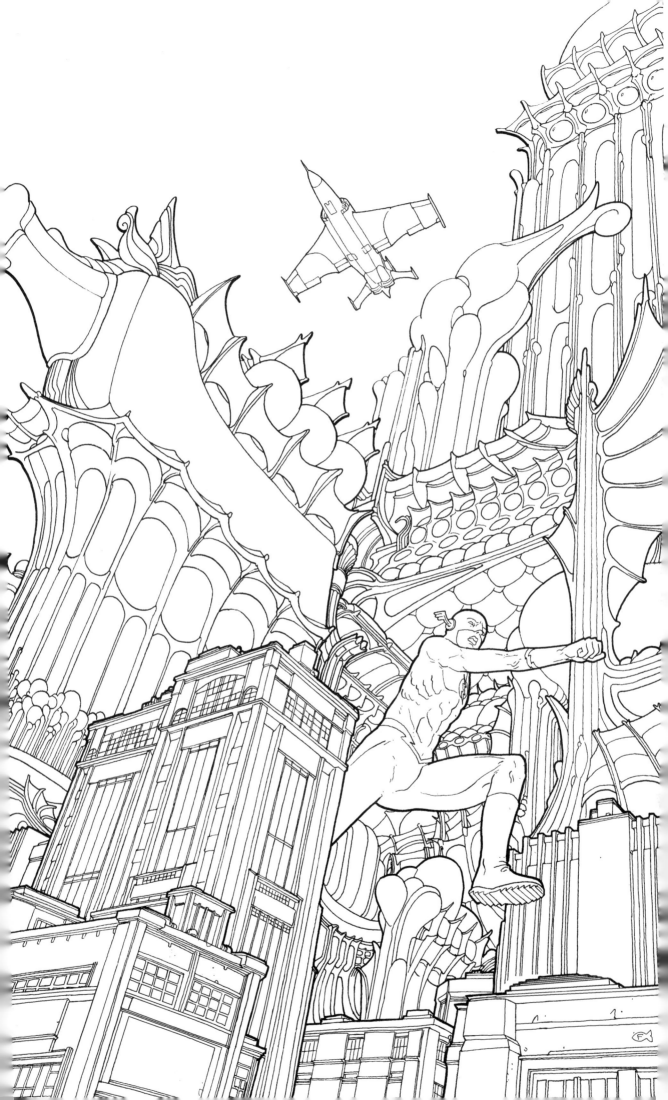

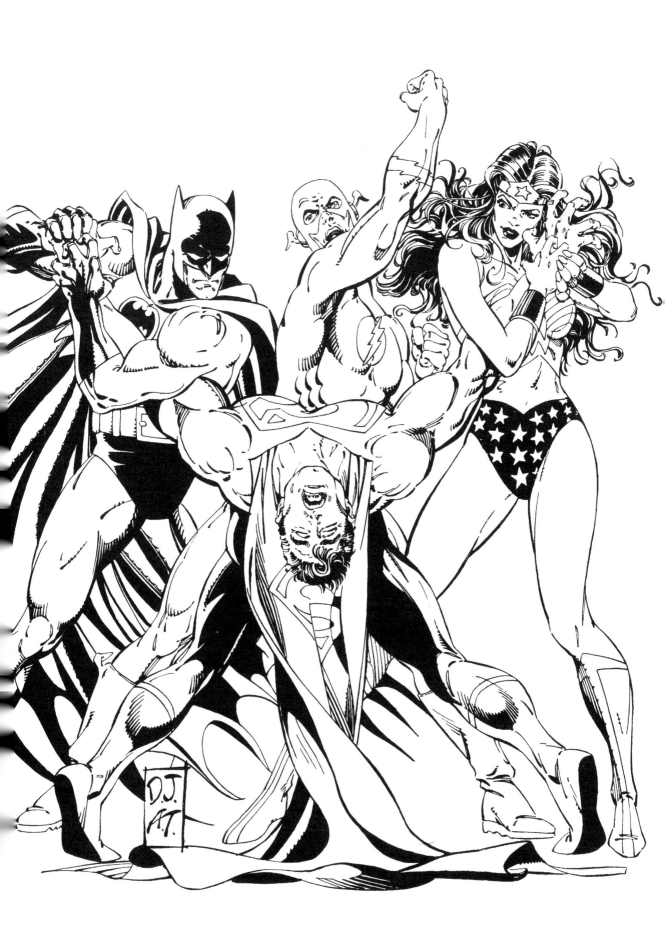

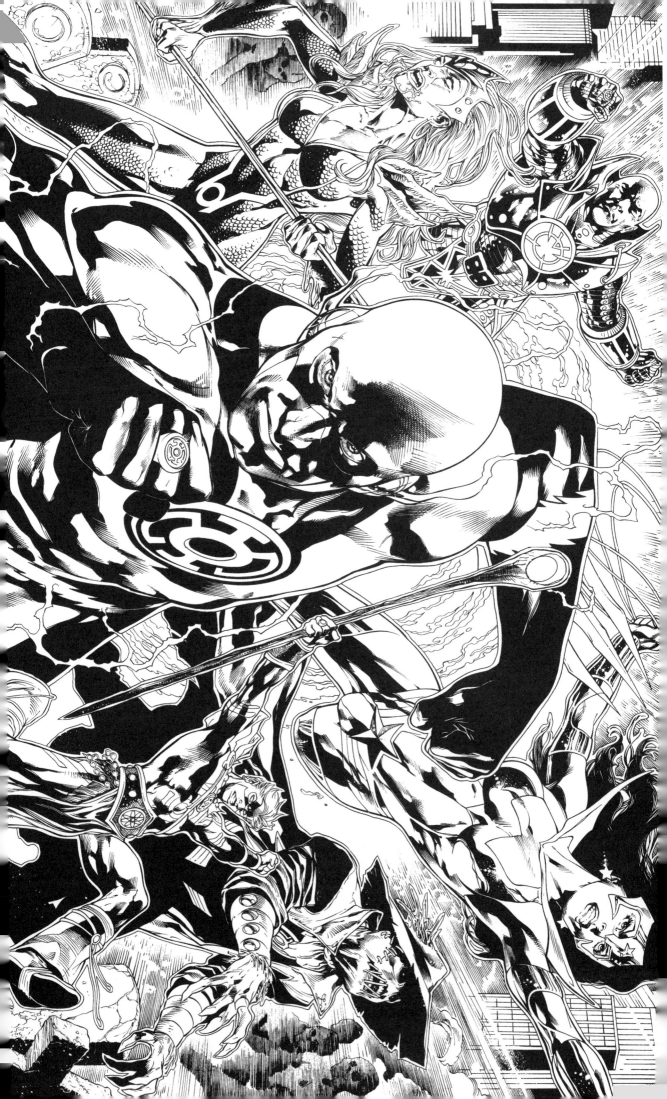

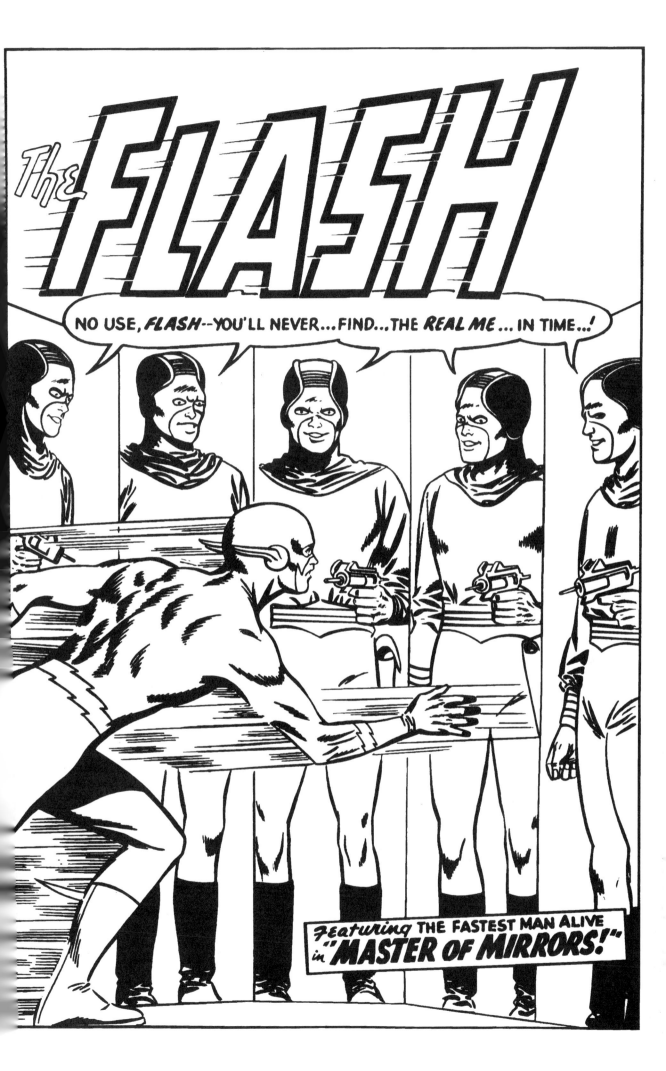

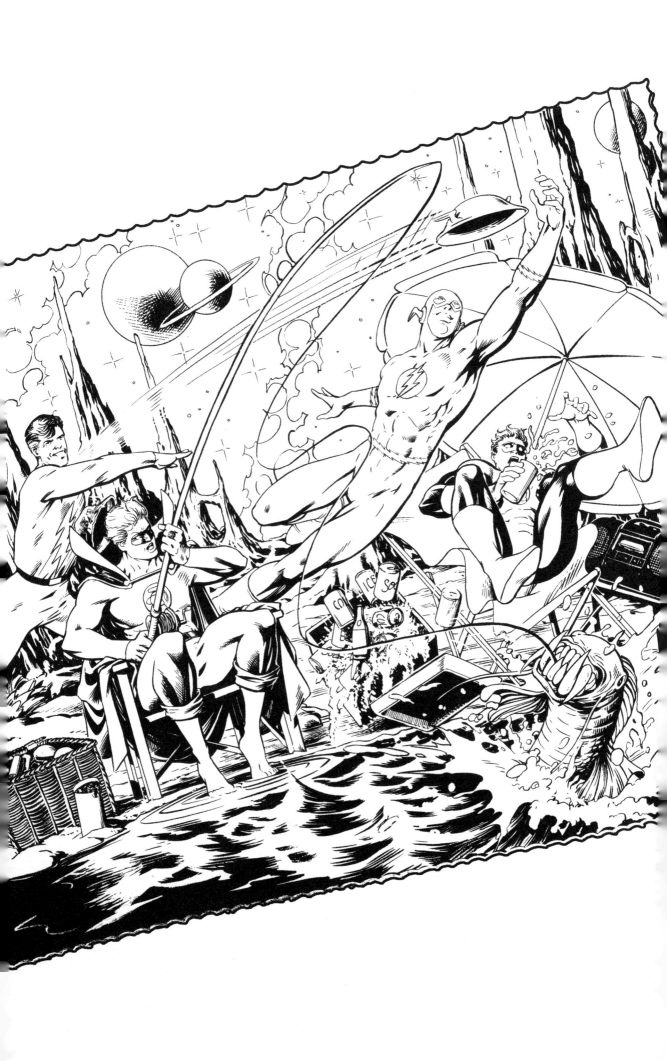

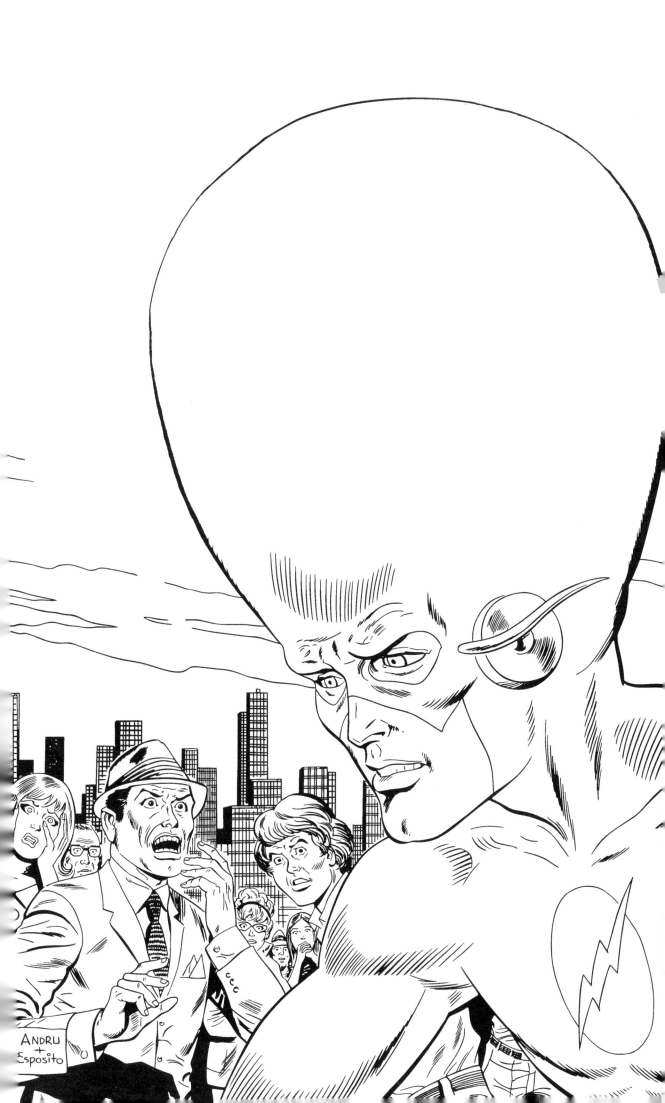

ANDRU
+
Esposito

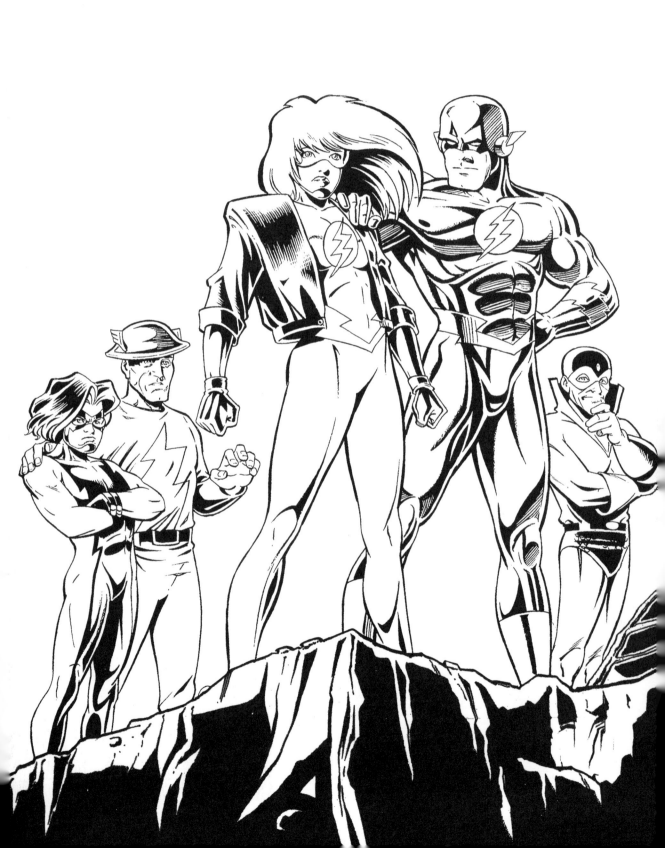

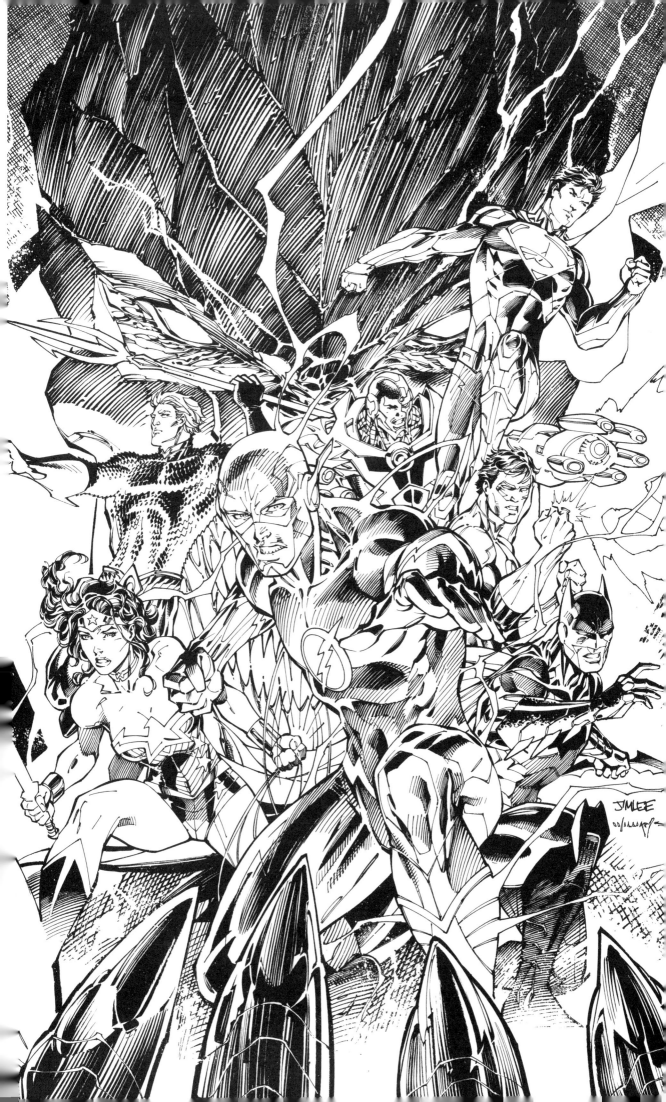

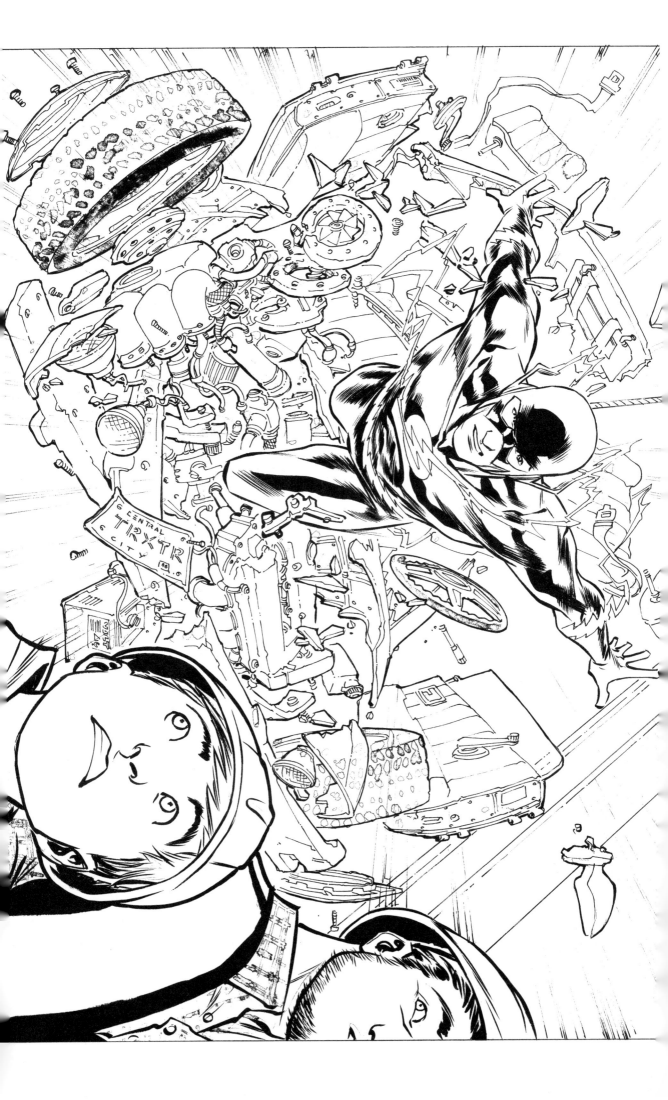

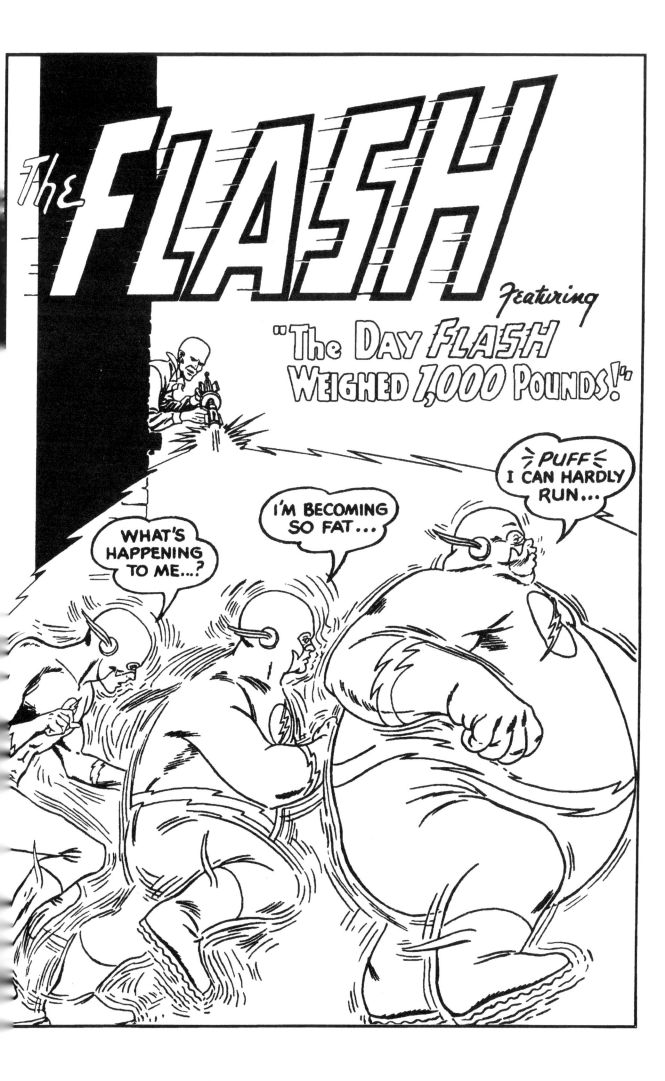

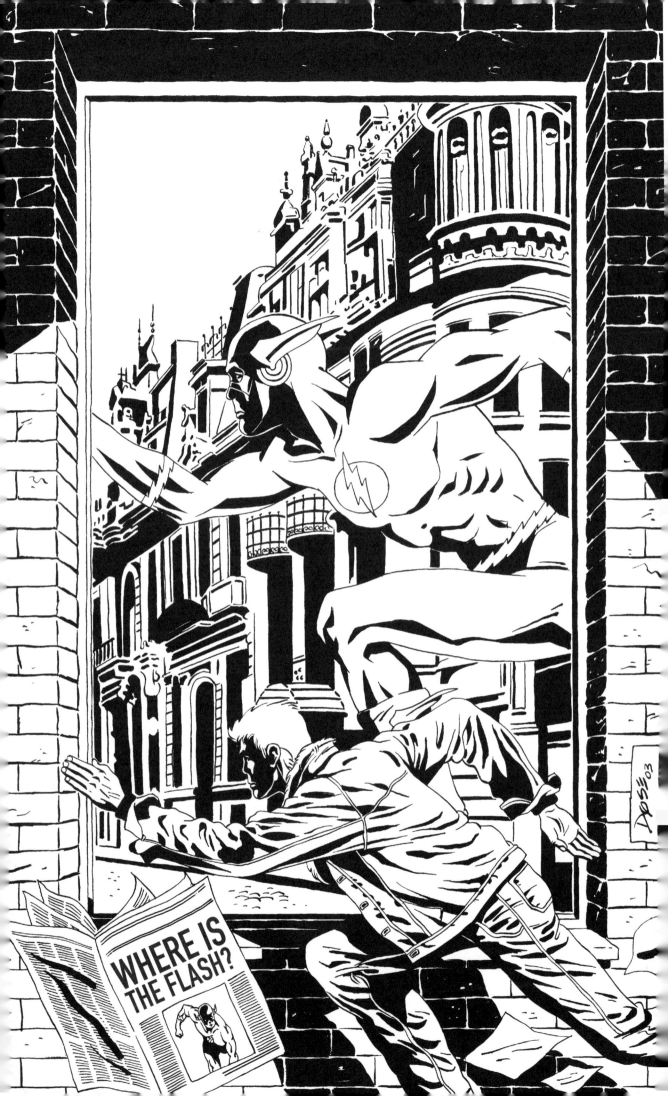

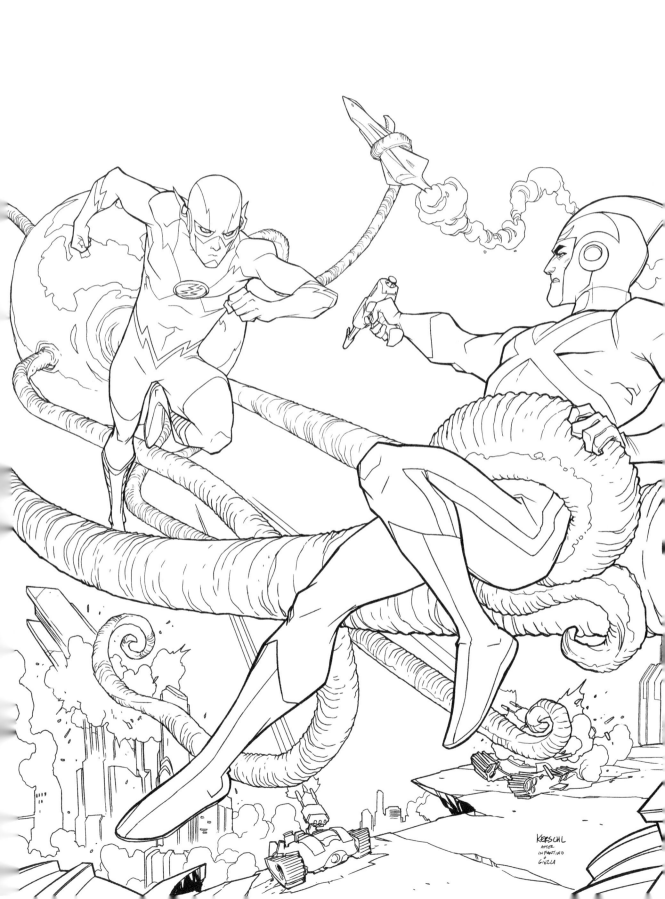

KERSCHL
AFTER
INFANTINO
&
GIELLA

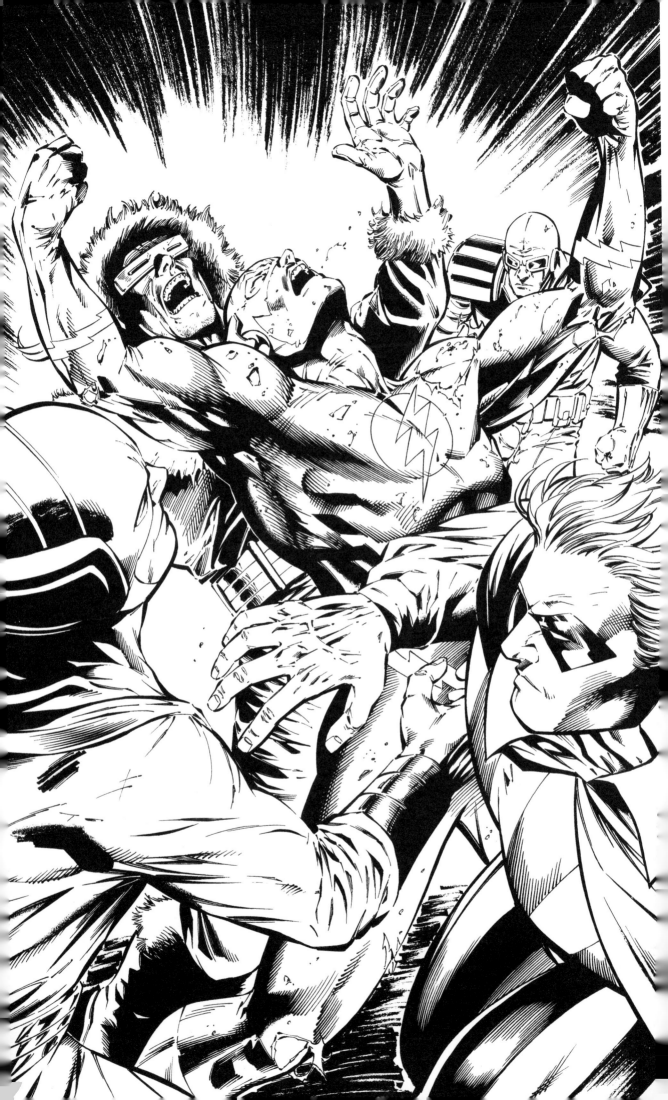

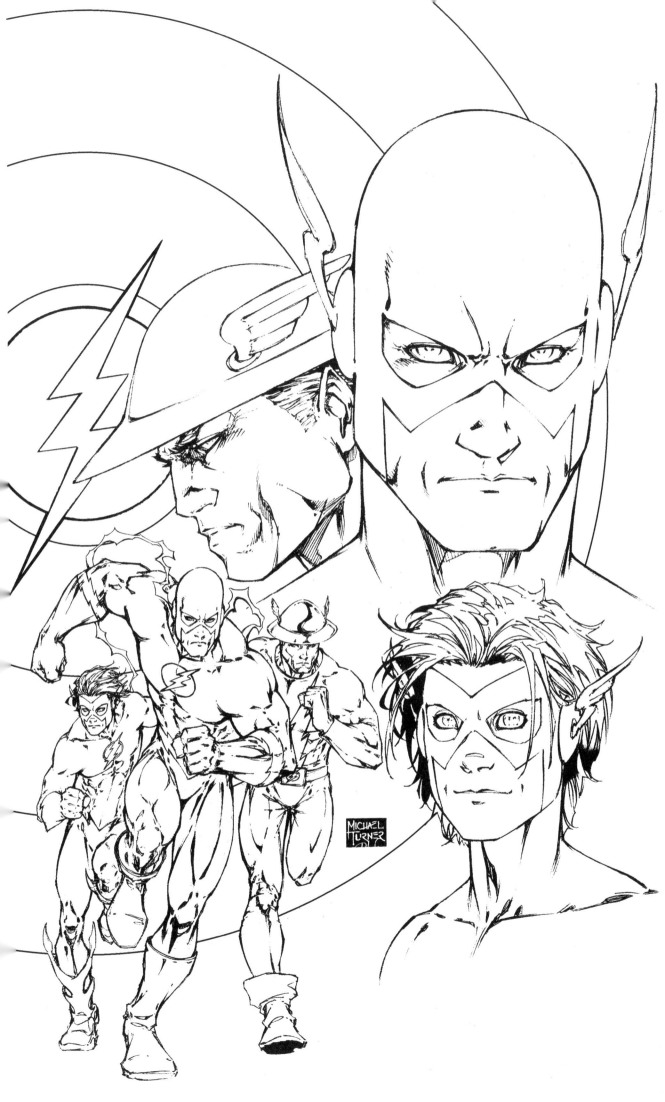

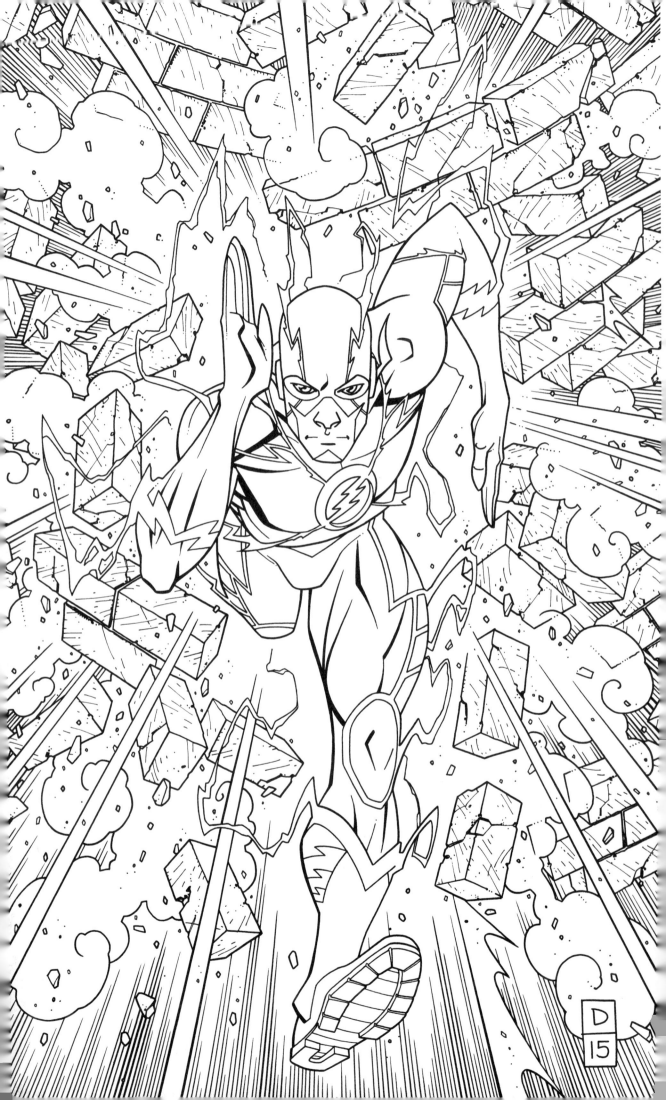

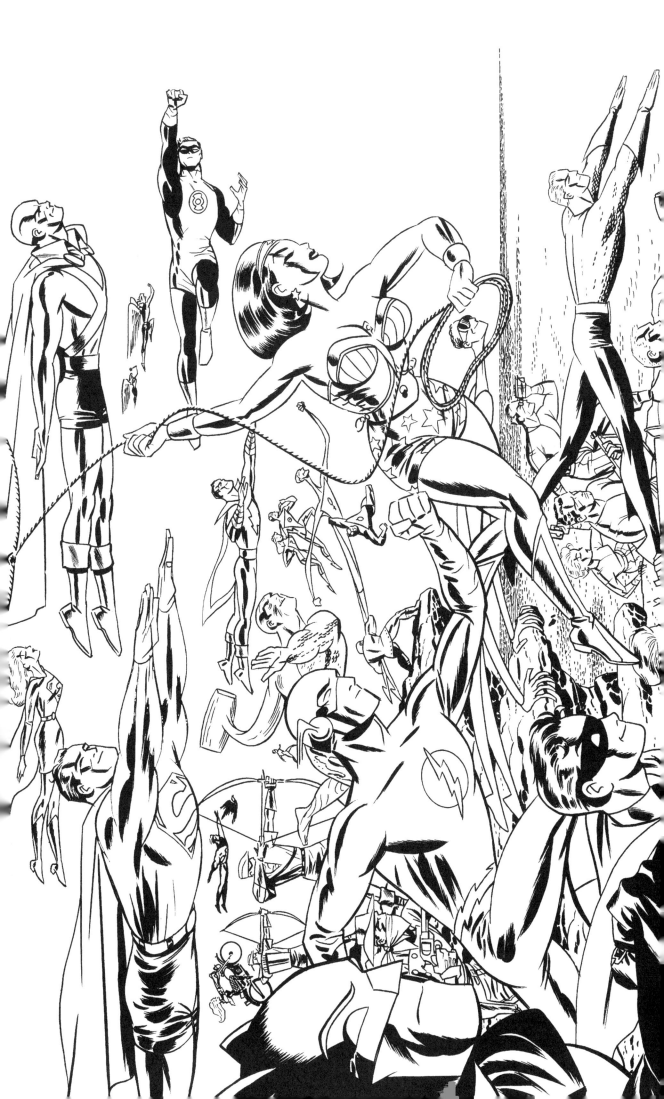

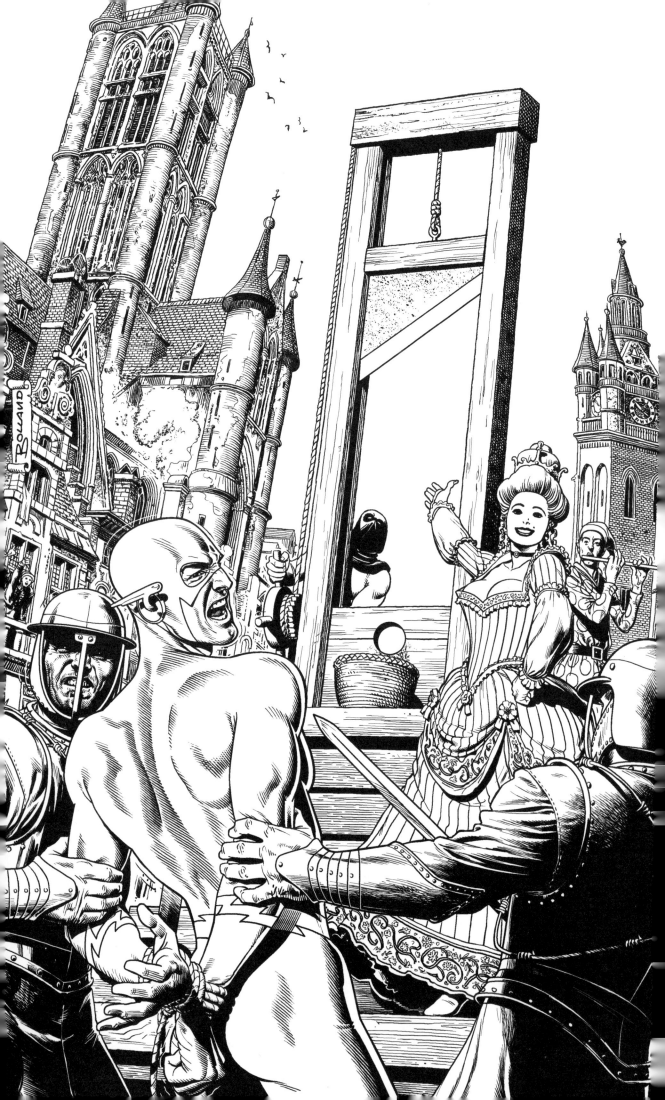

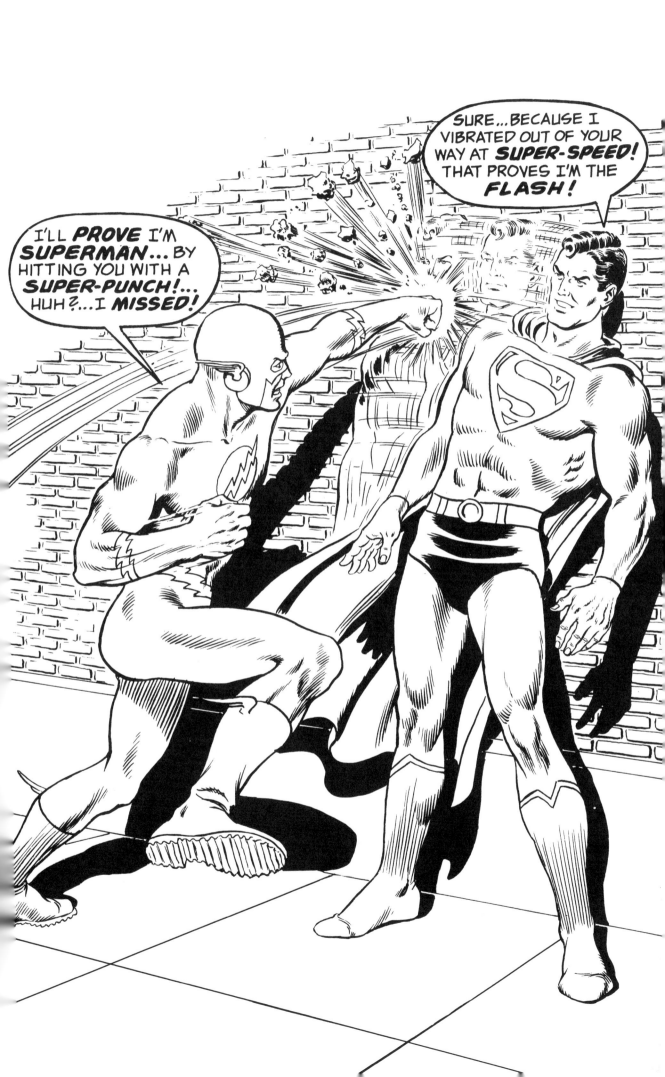

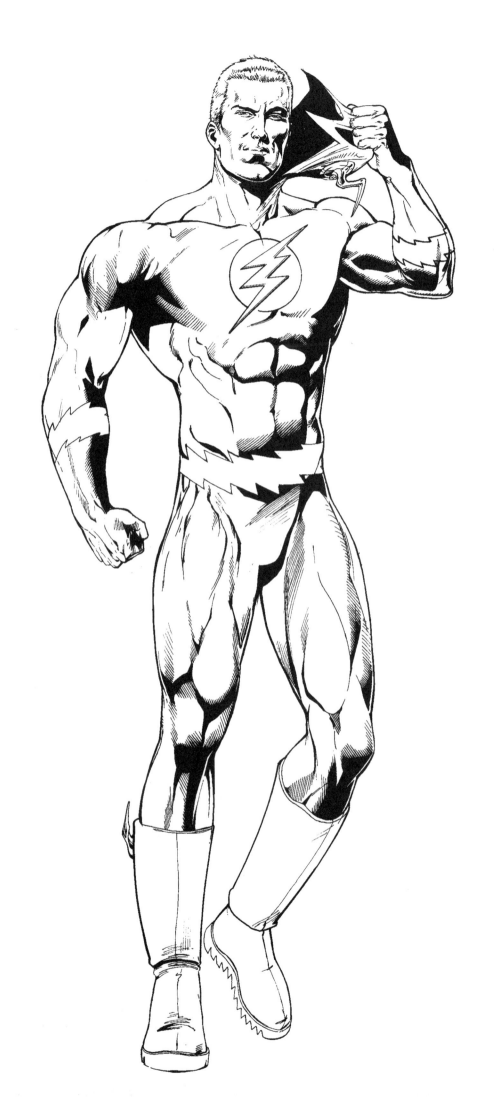

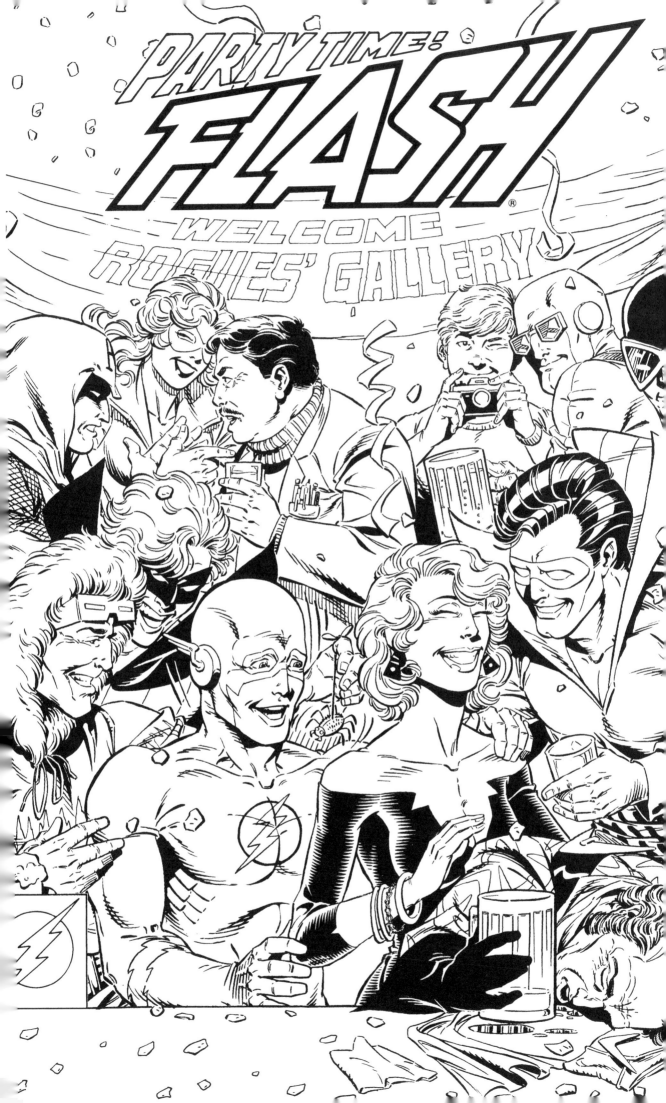

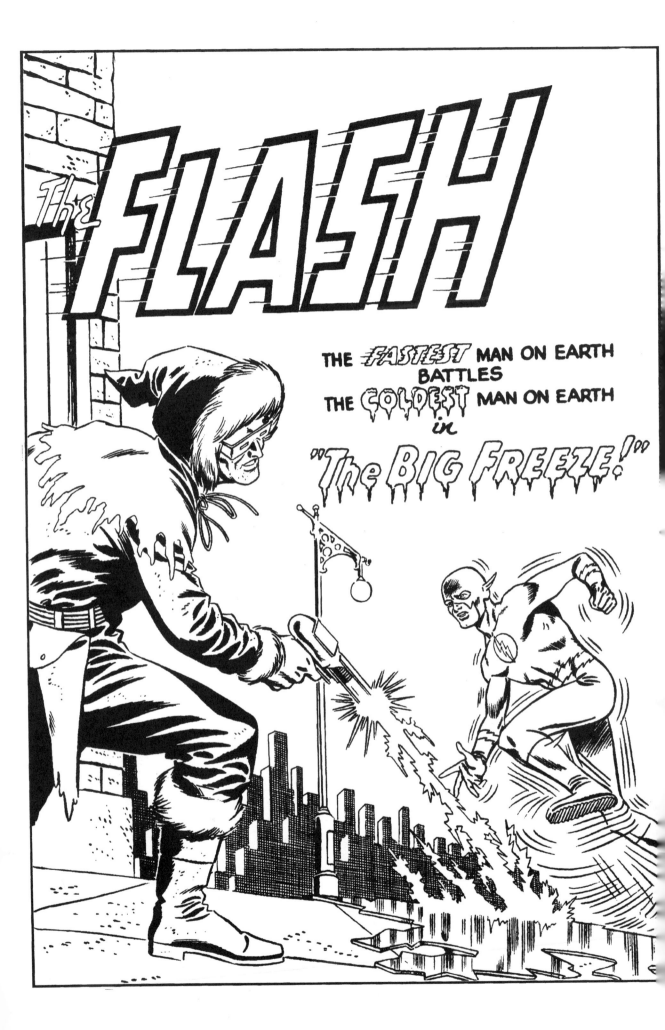

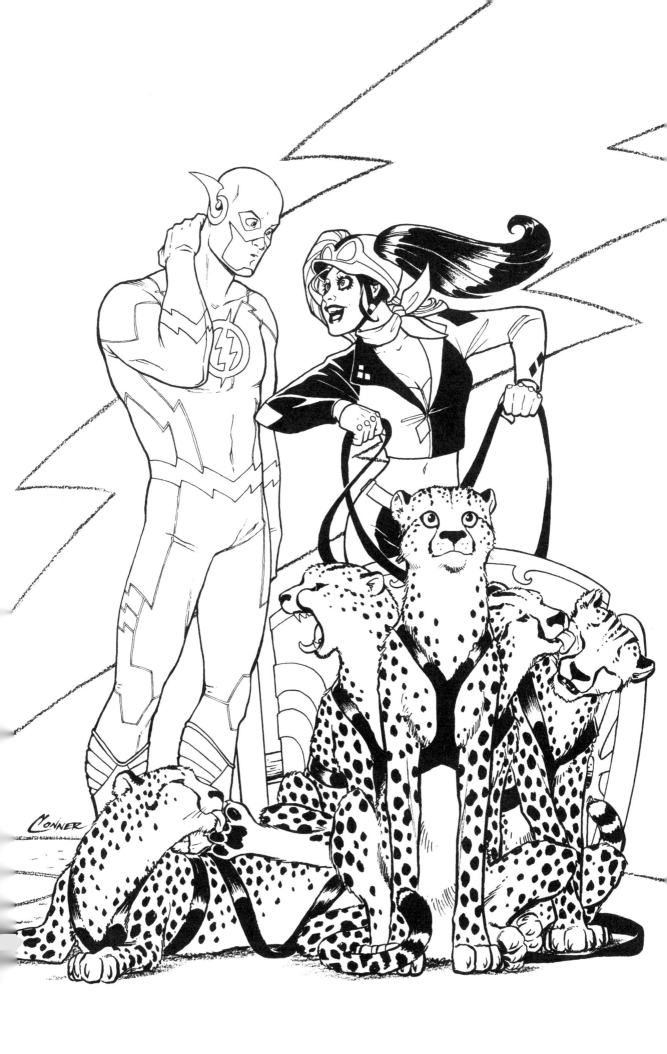

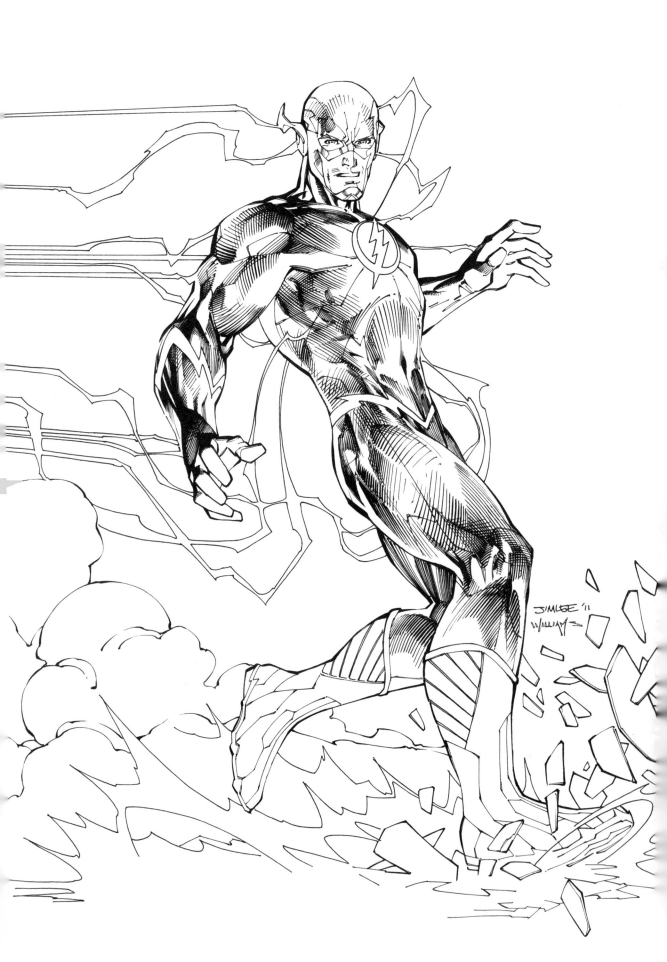

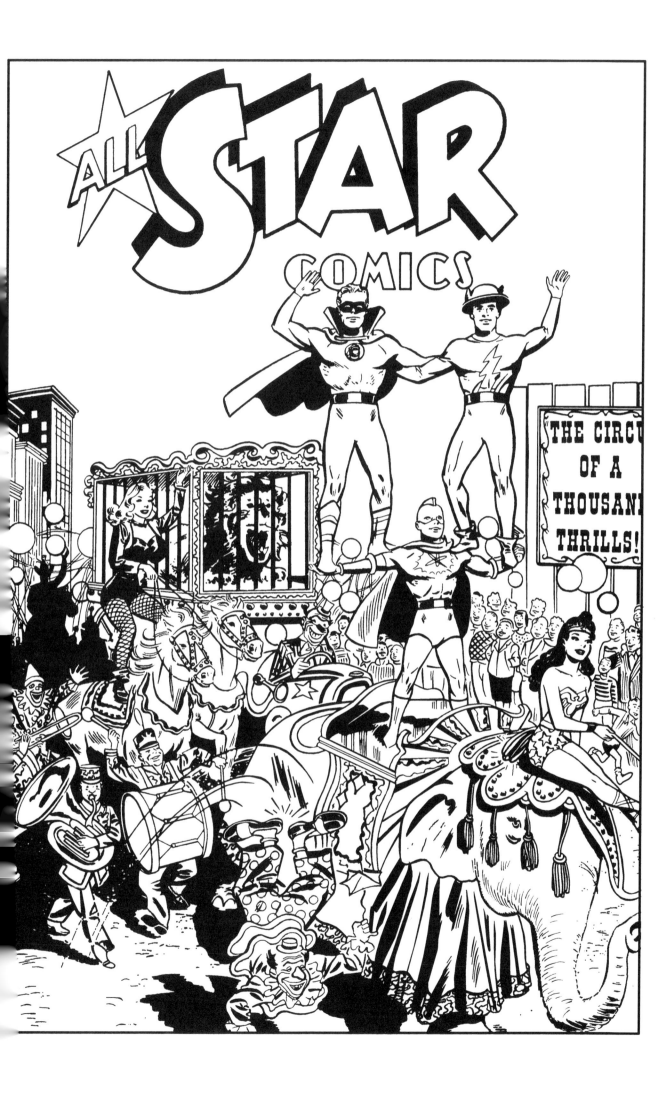

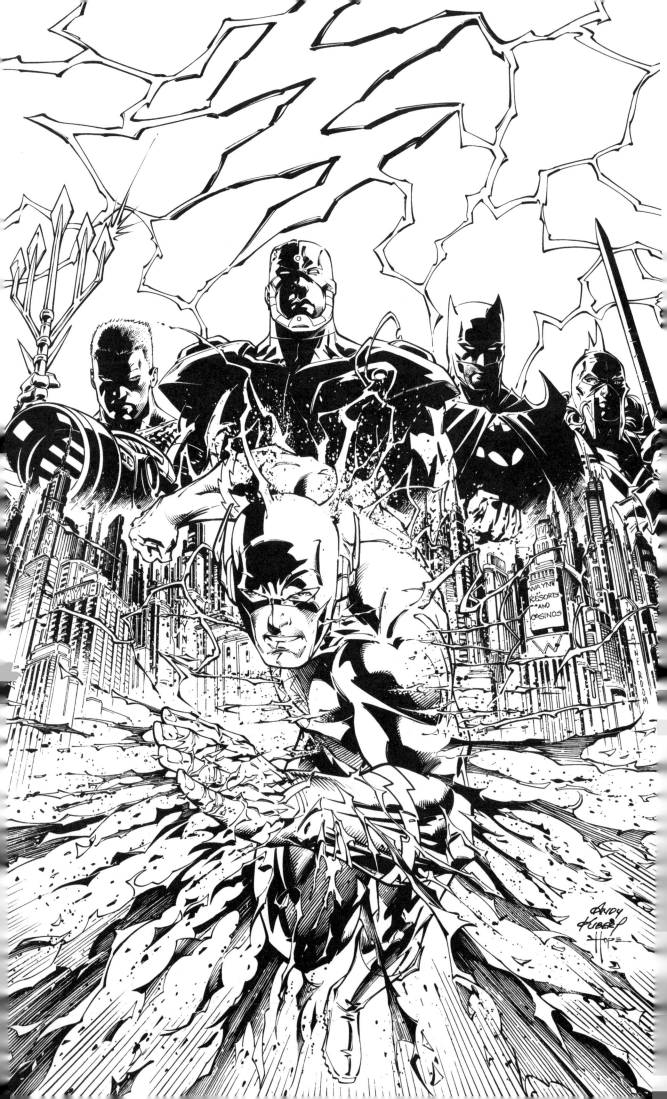

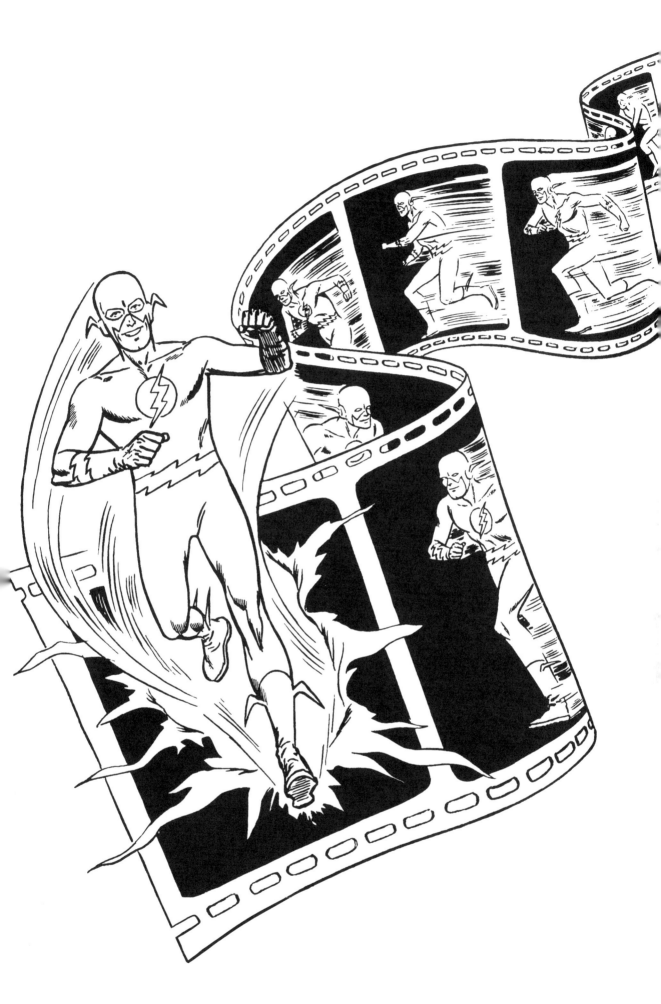

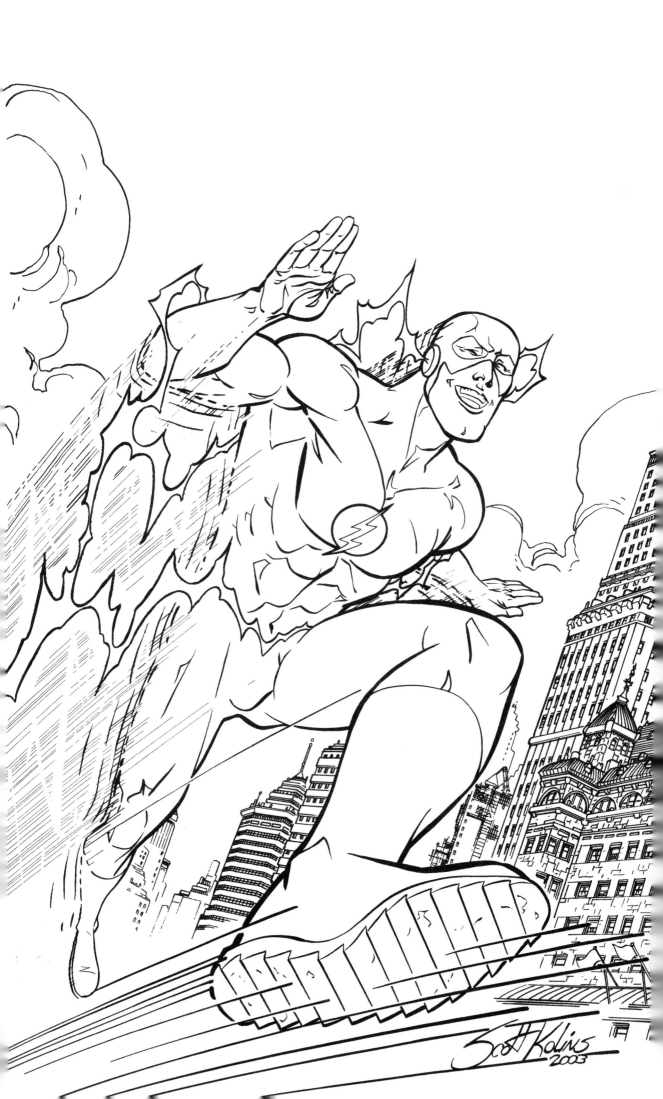

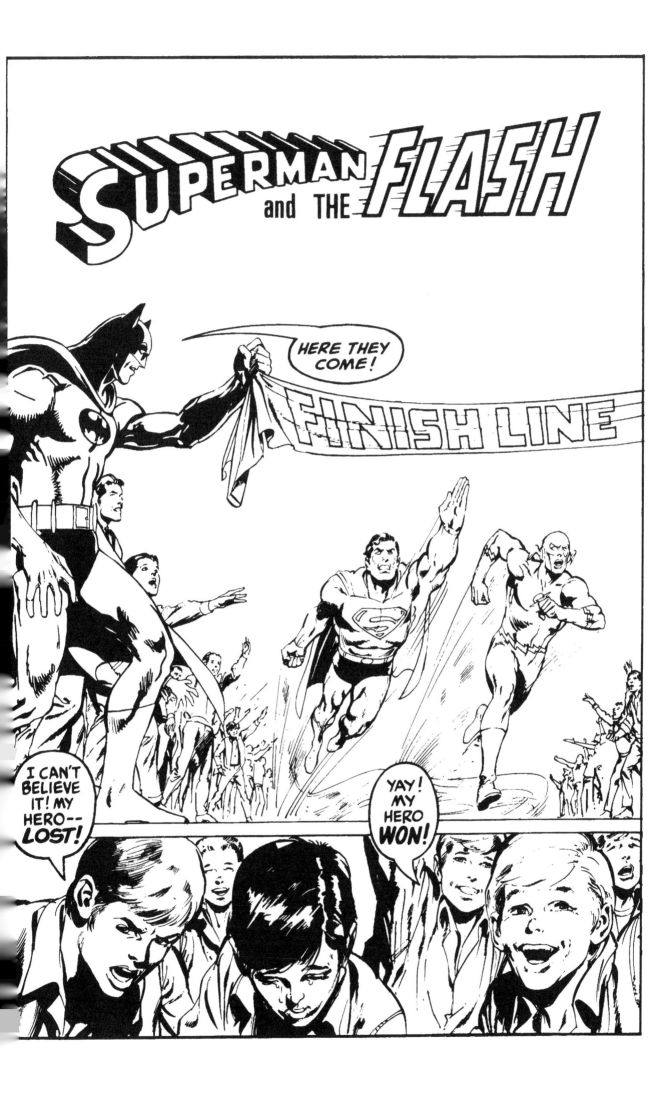

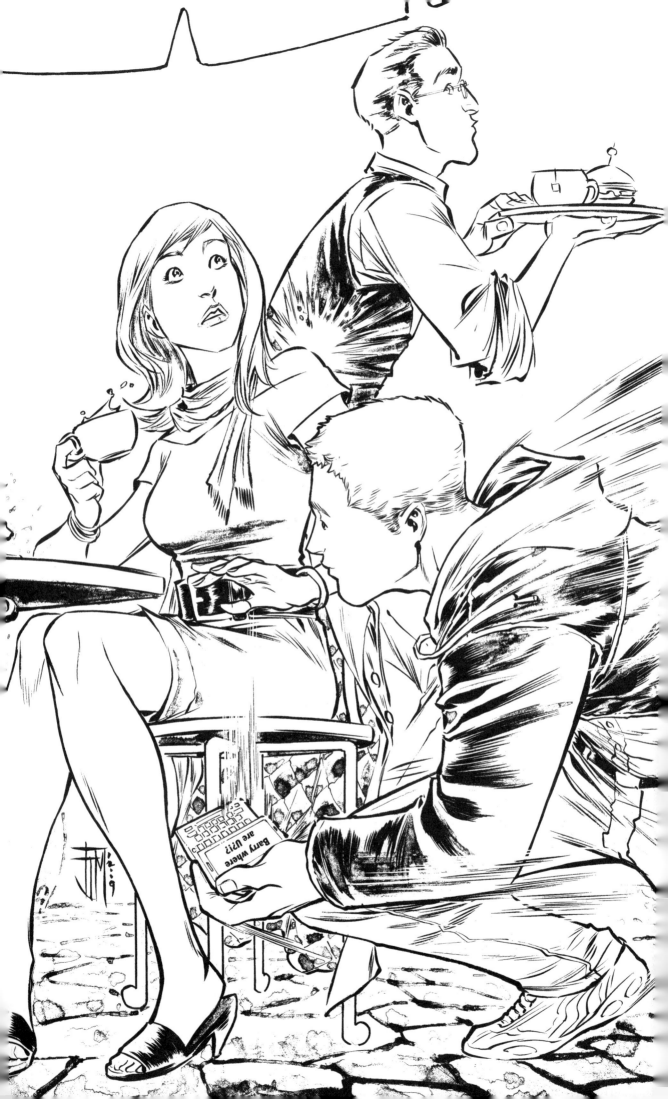

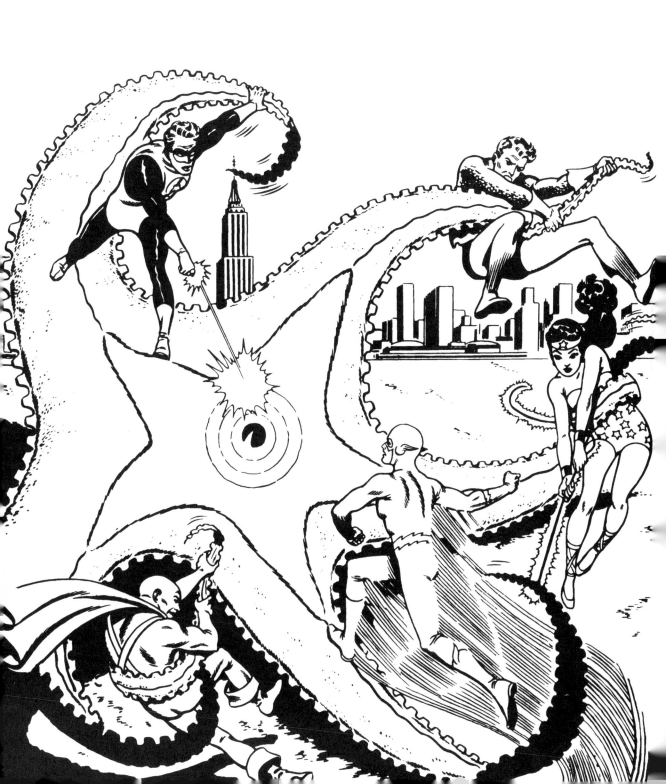

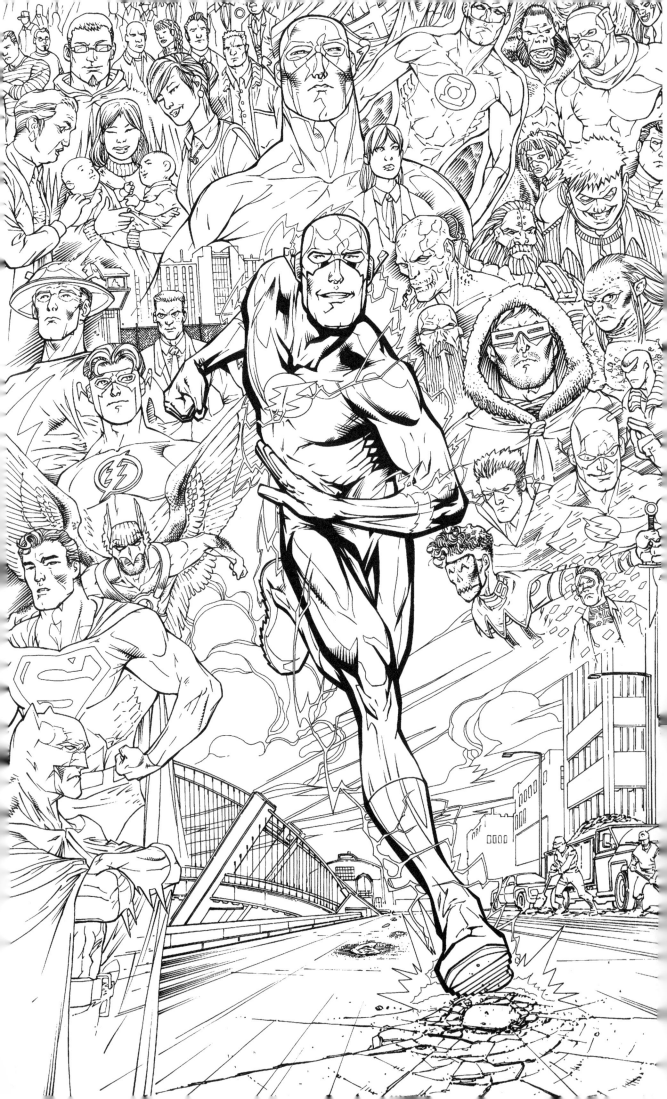

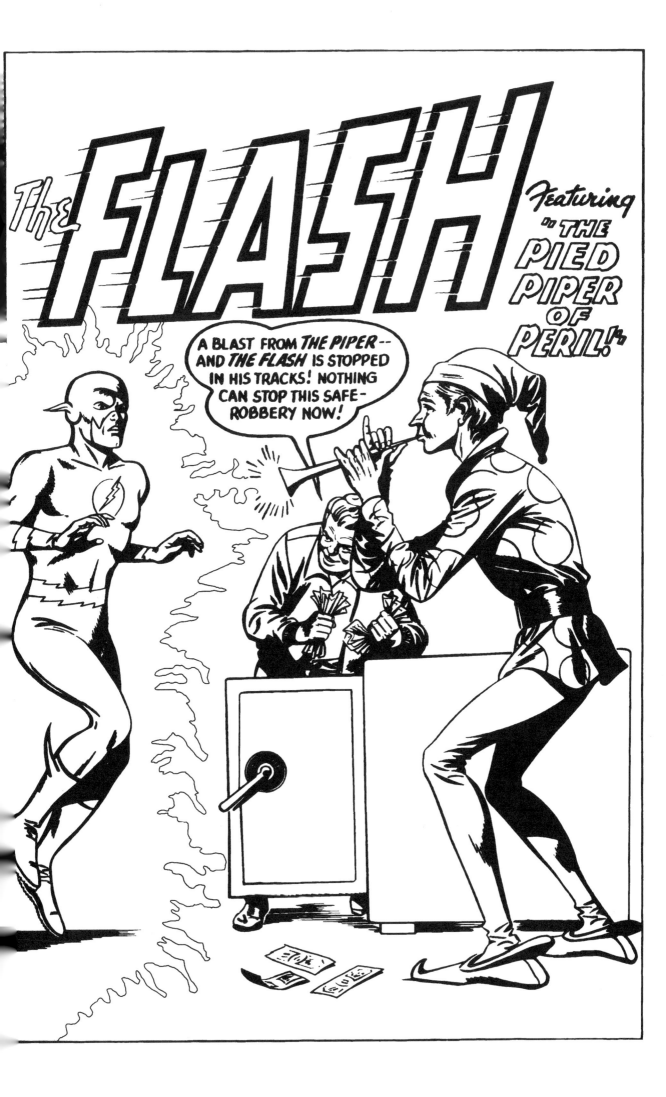

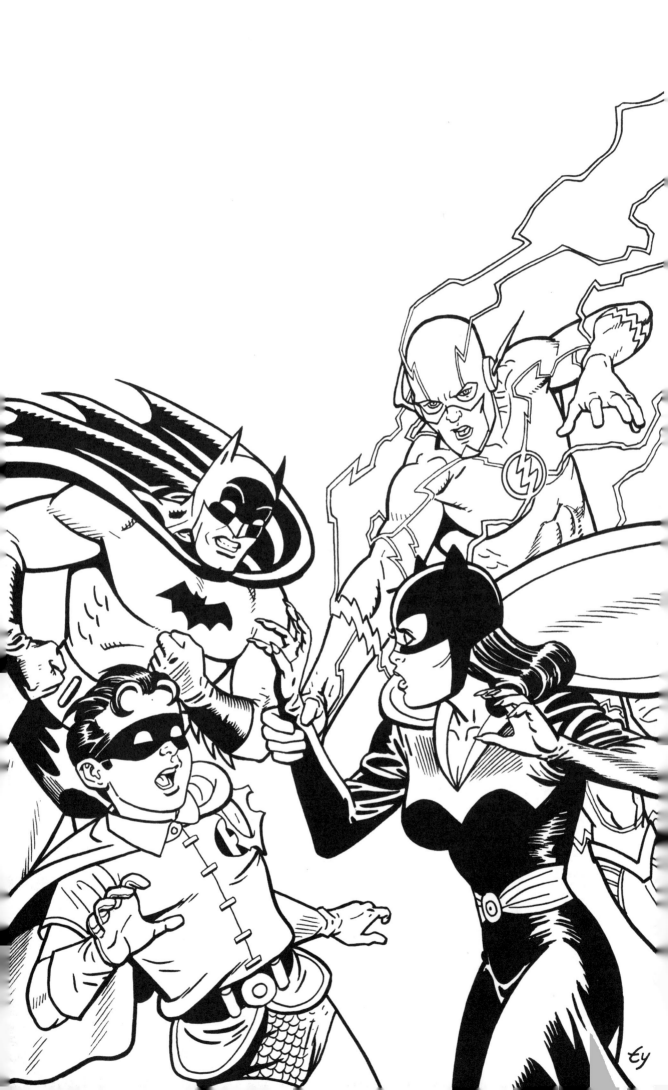

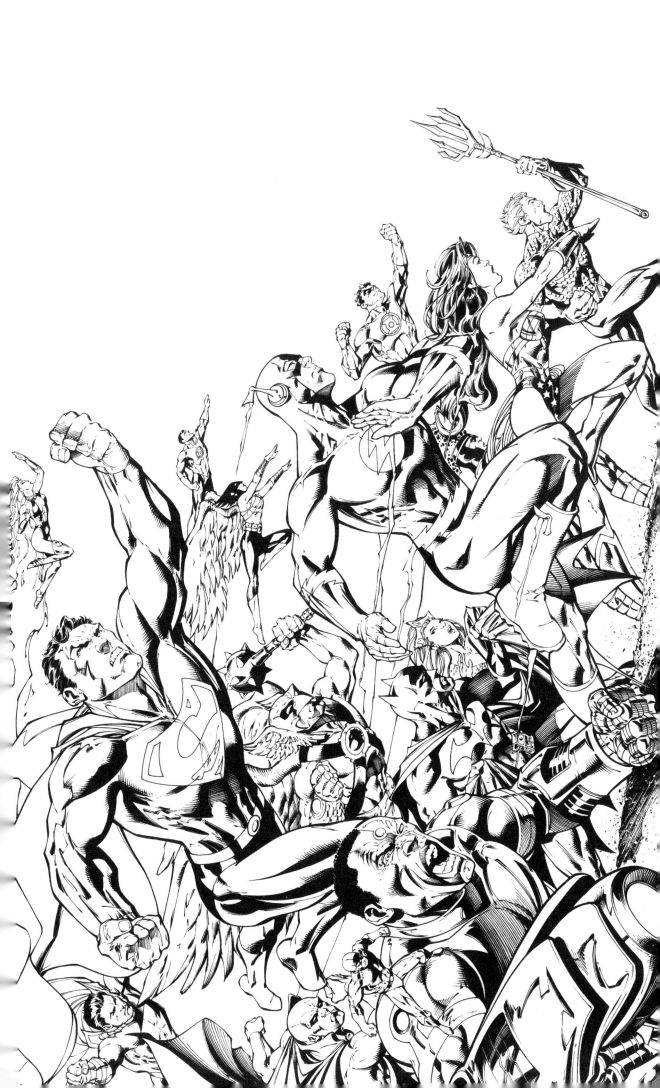

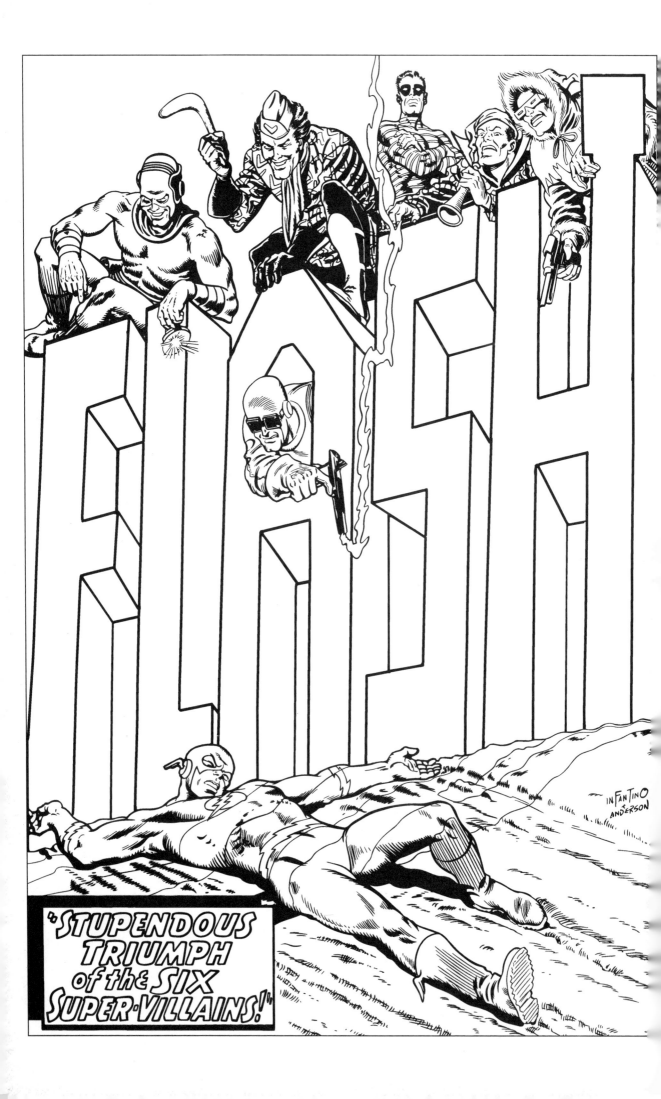

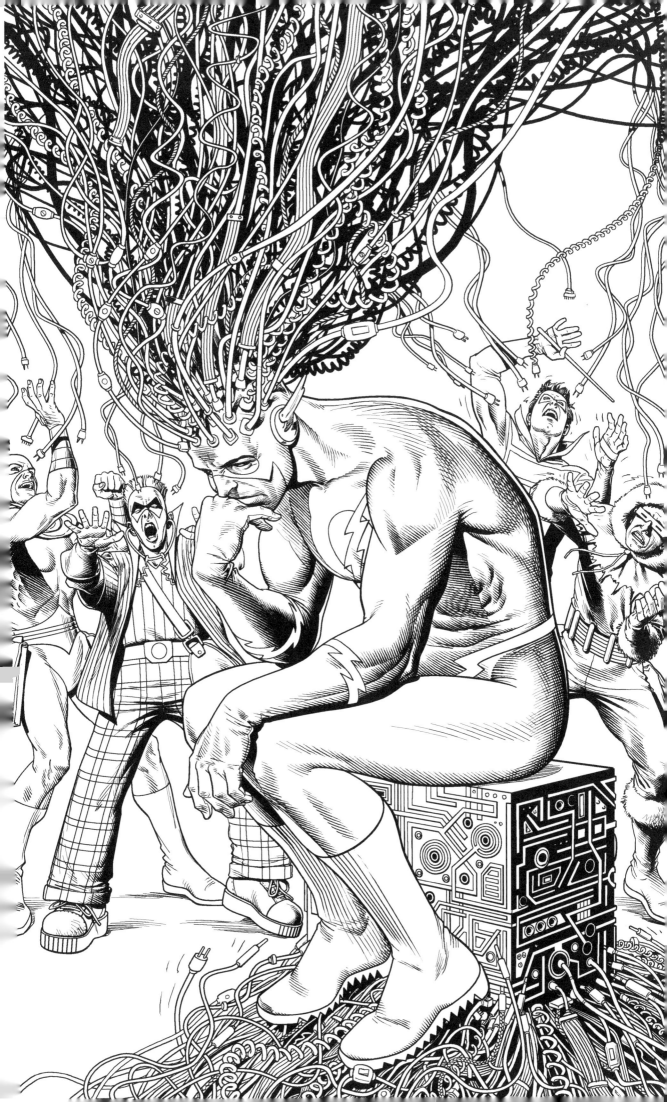

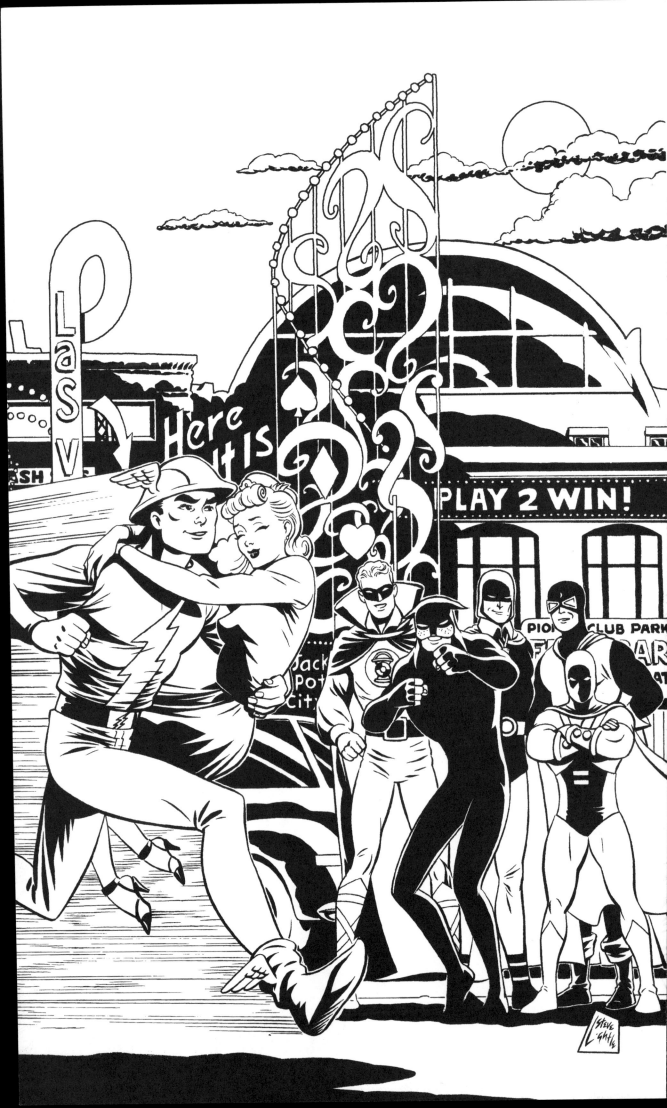

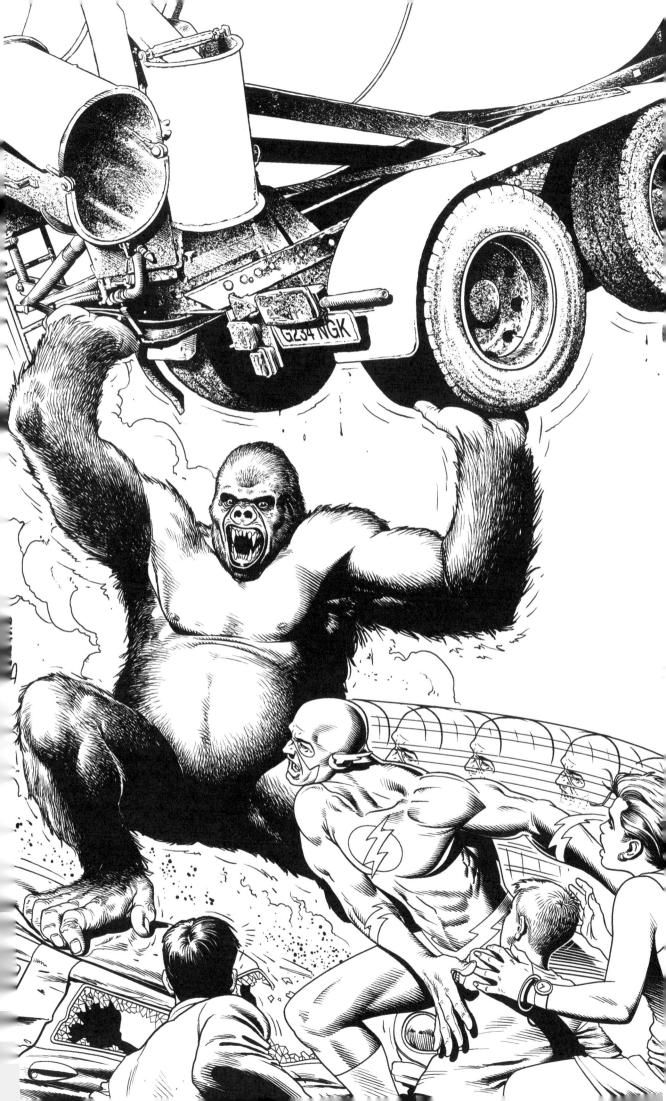

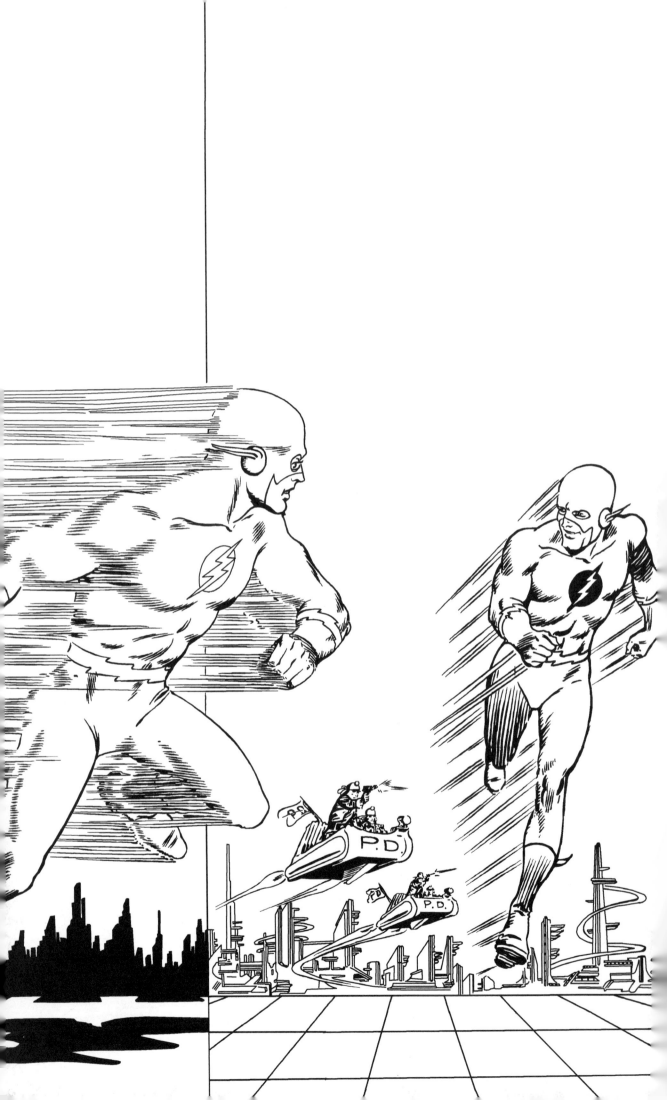

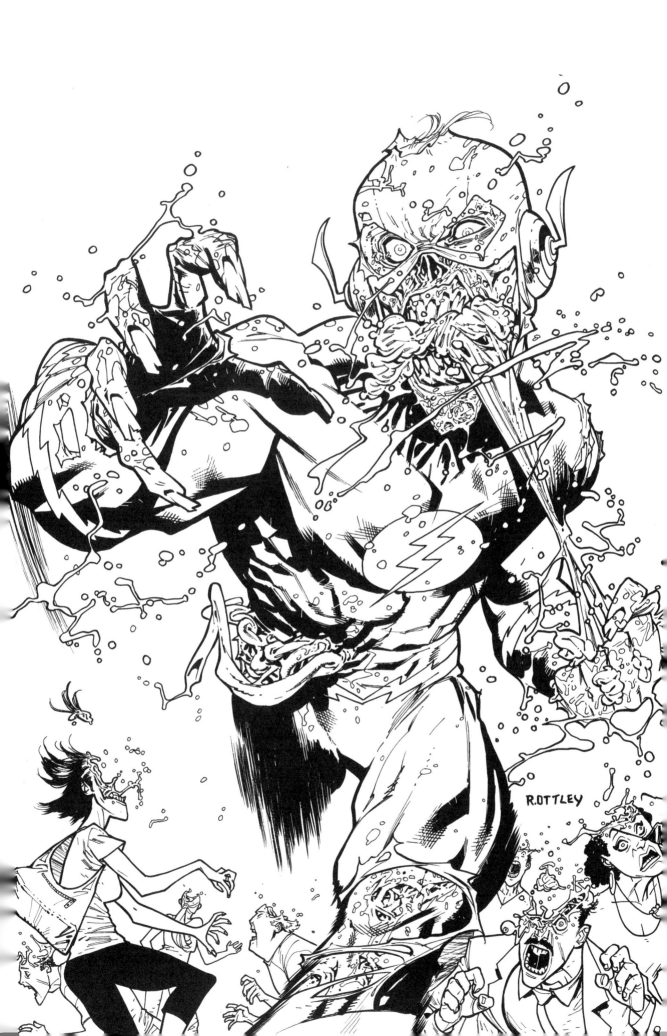

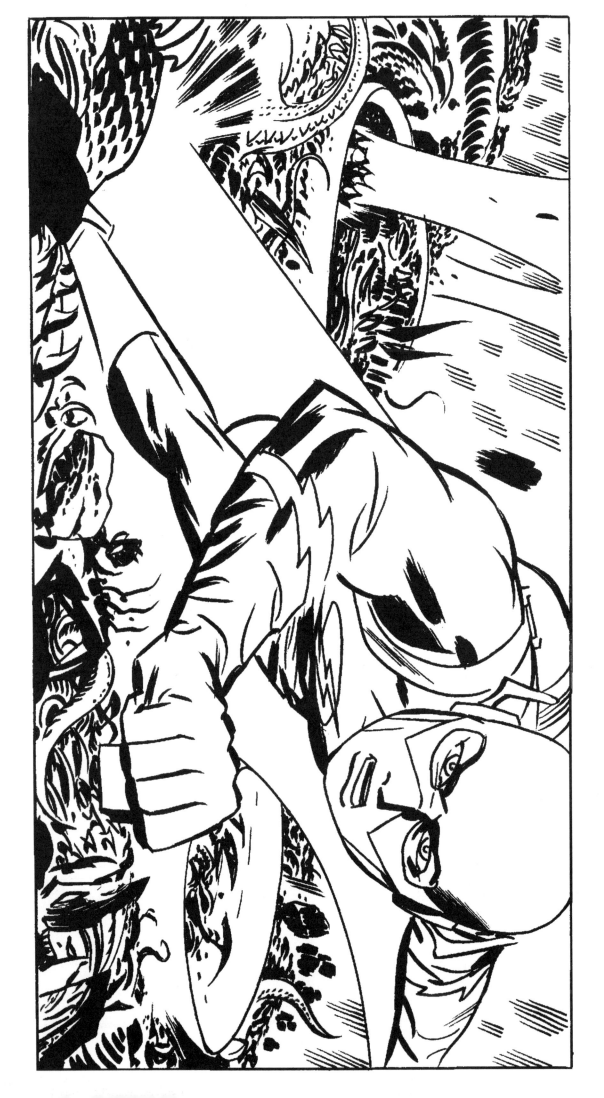

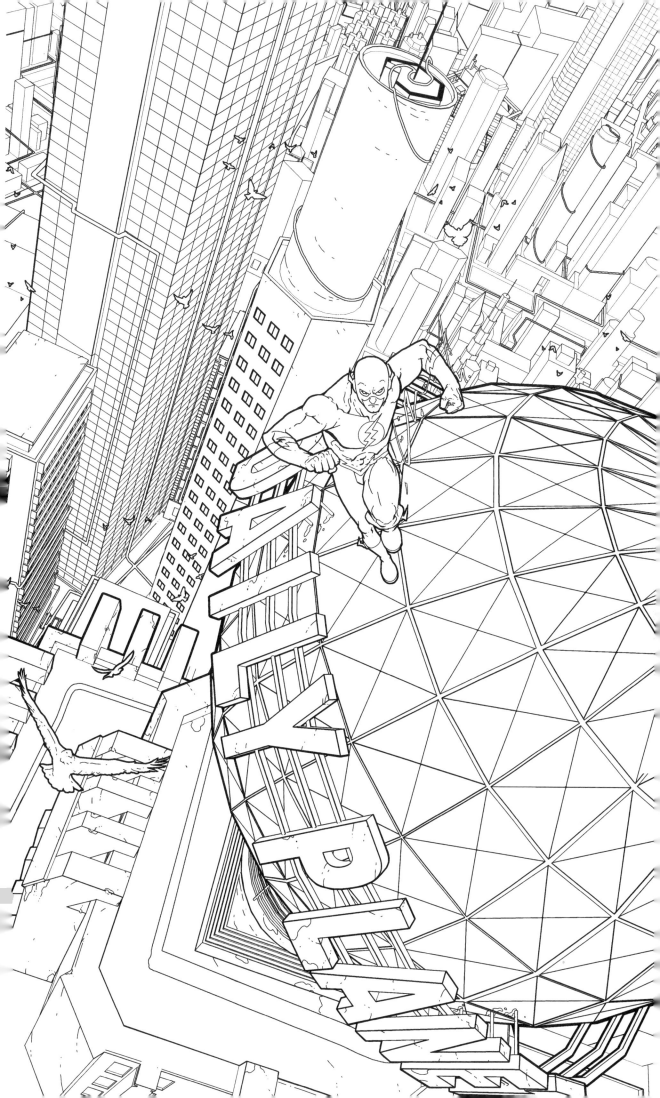

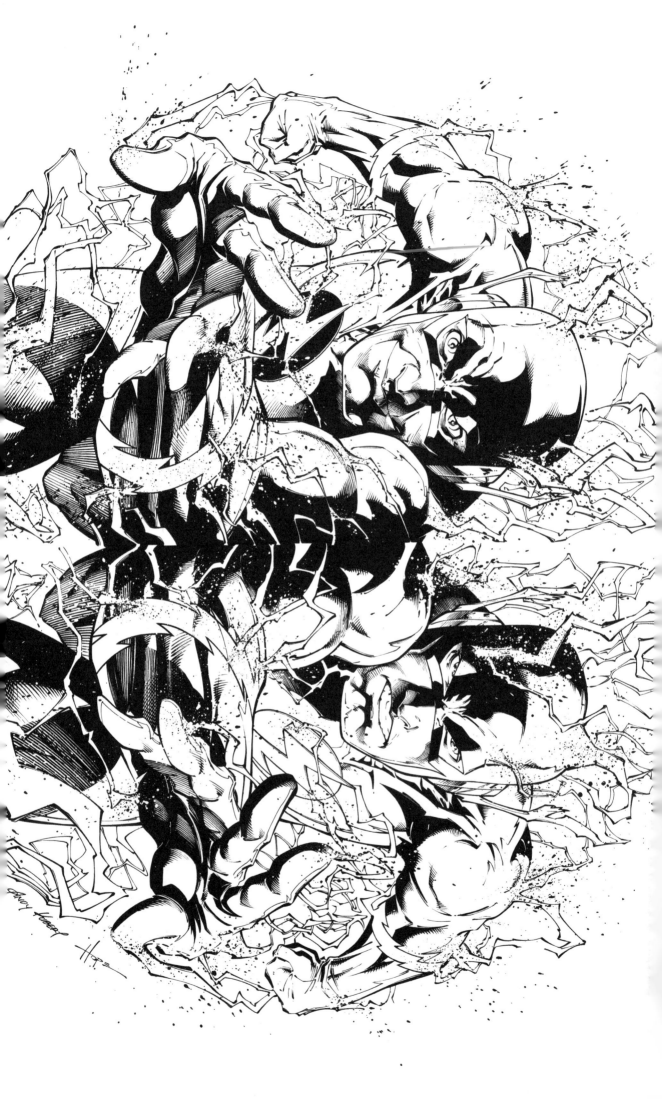

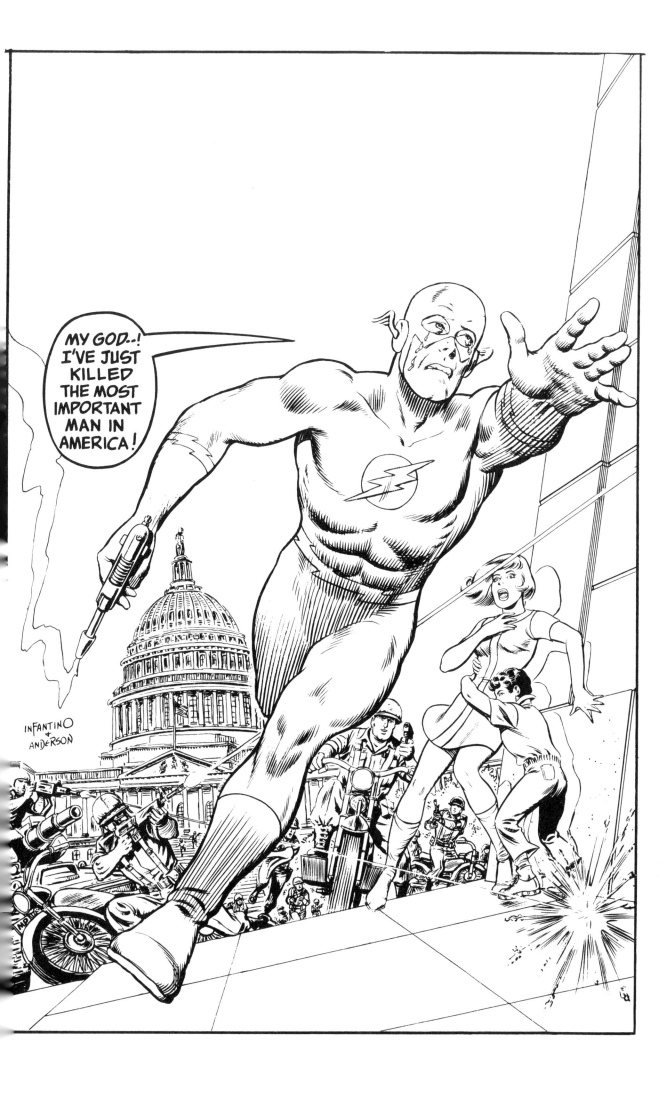

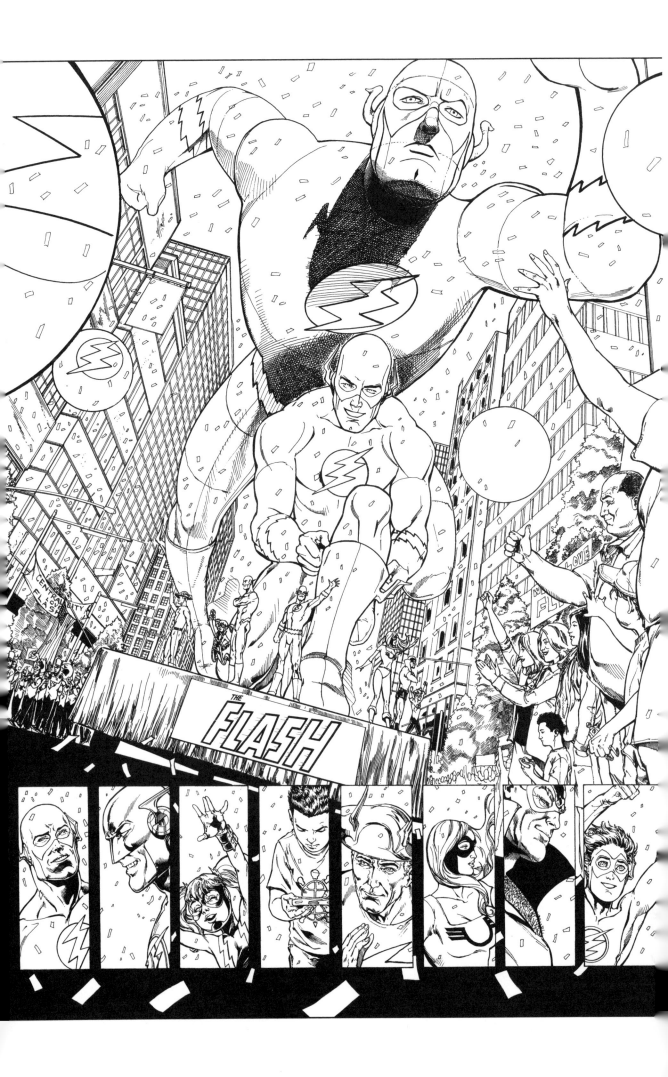

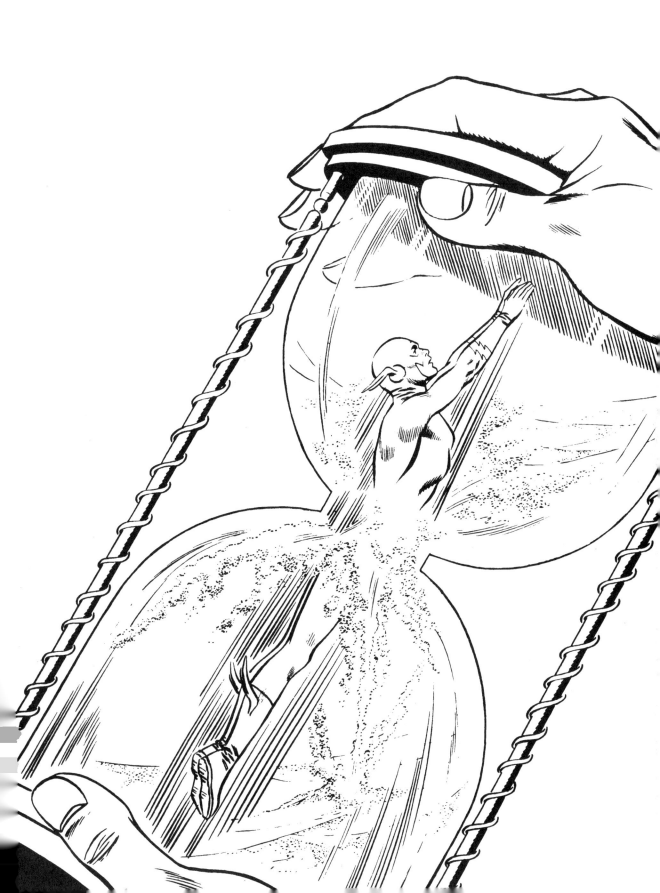

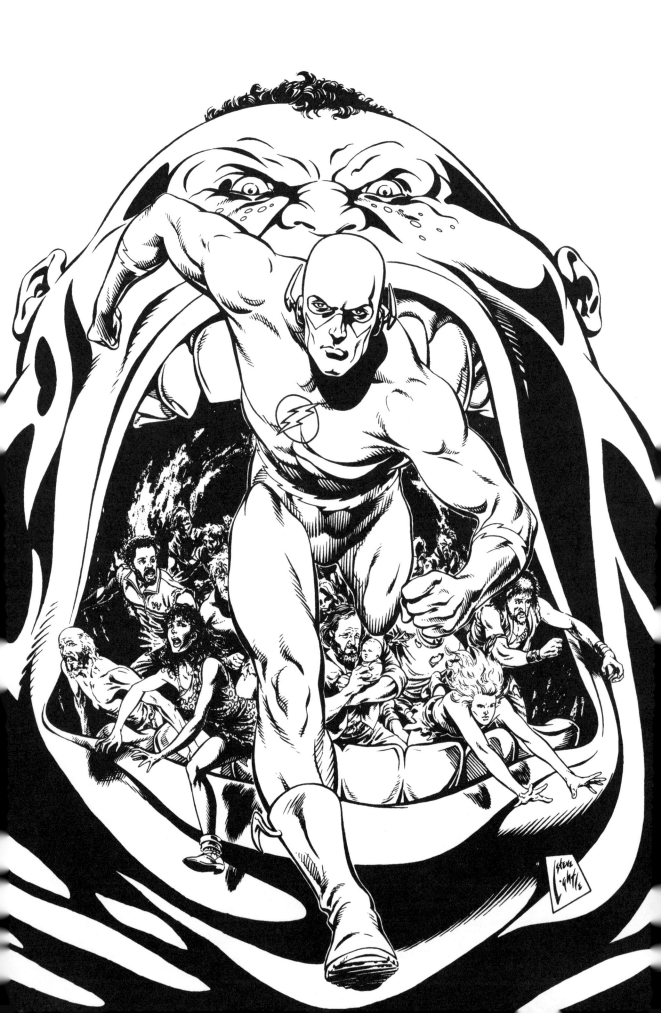

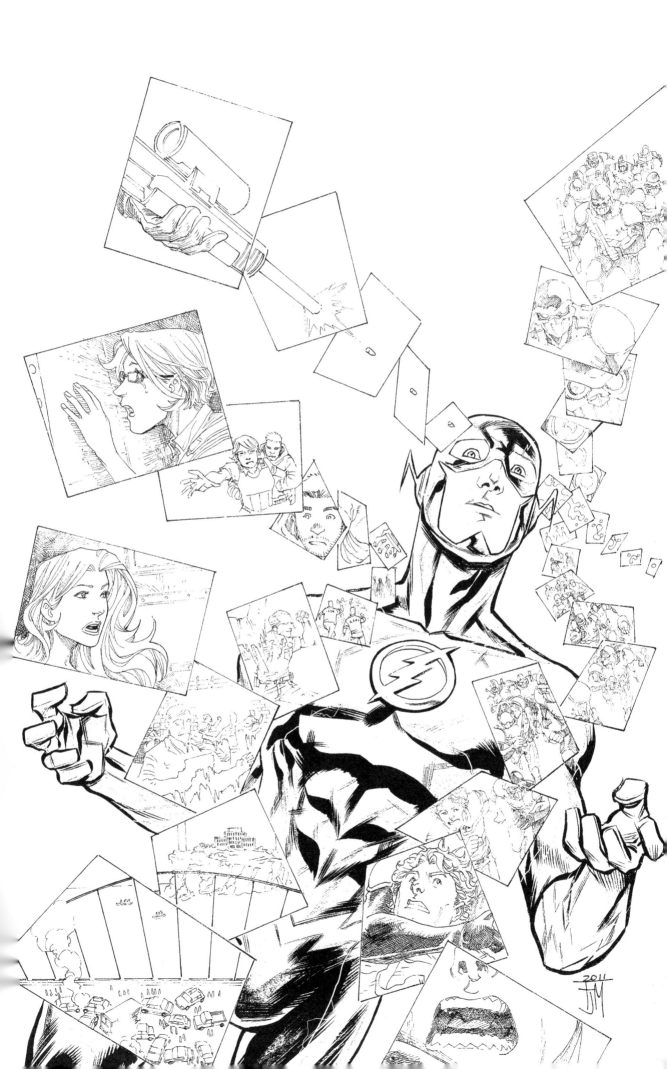

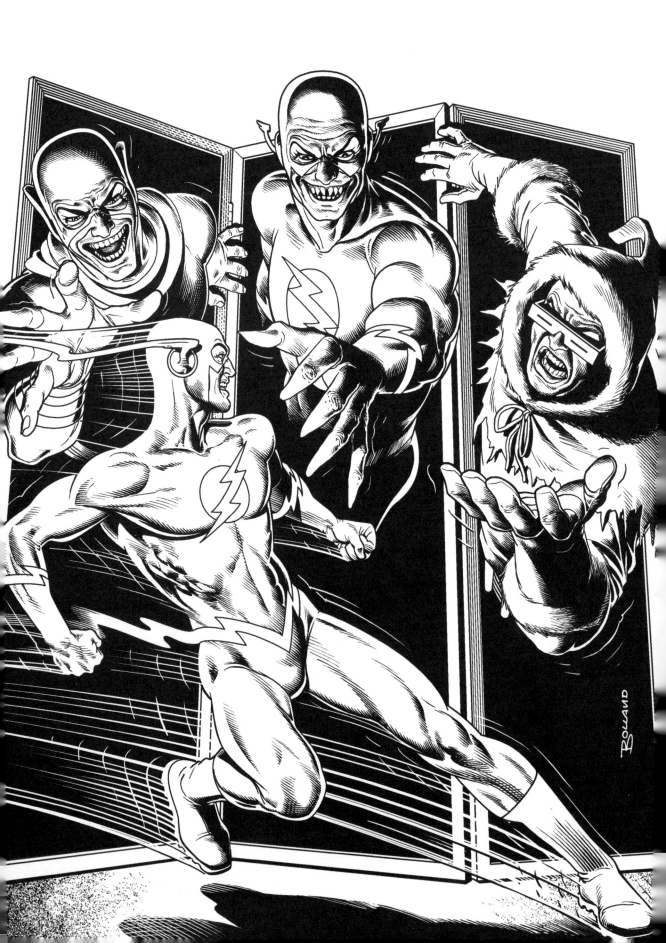

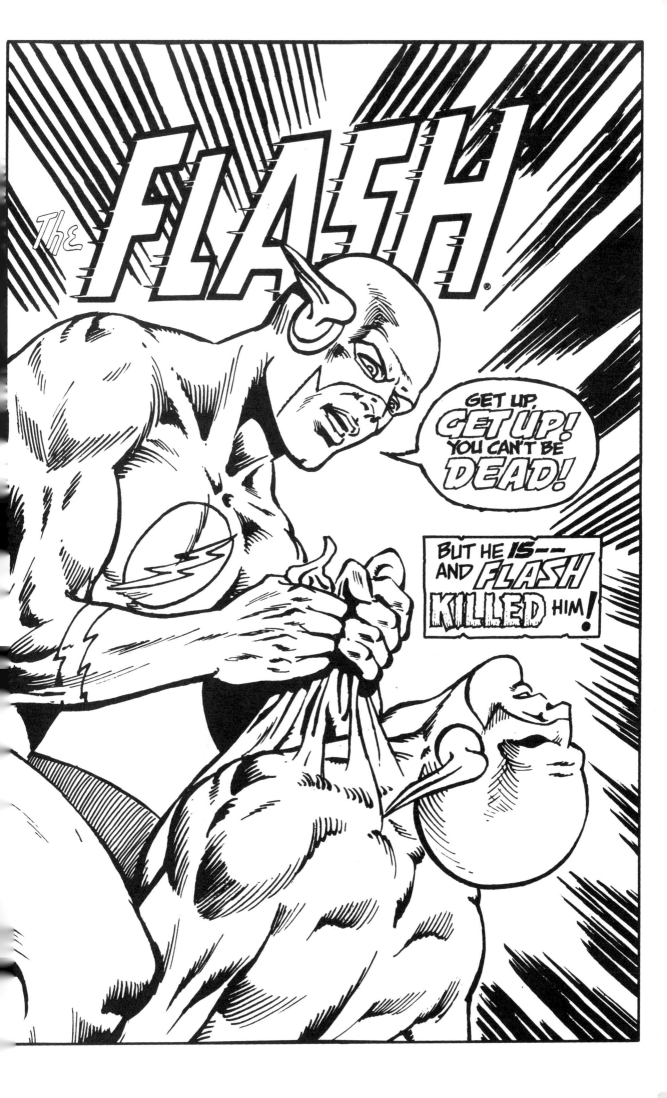

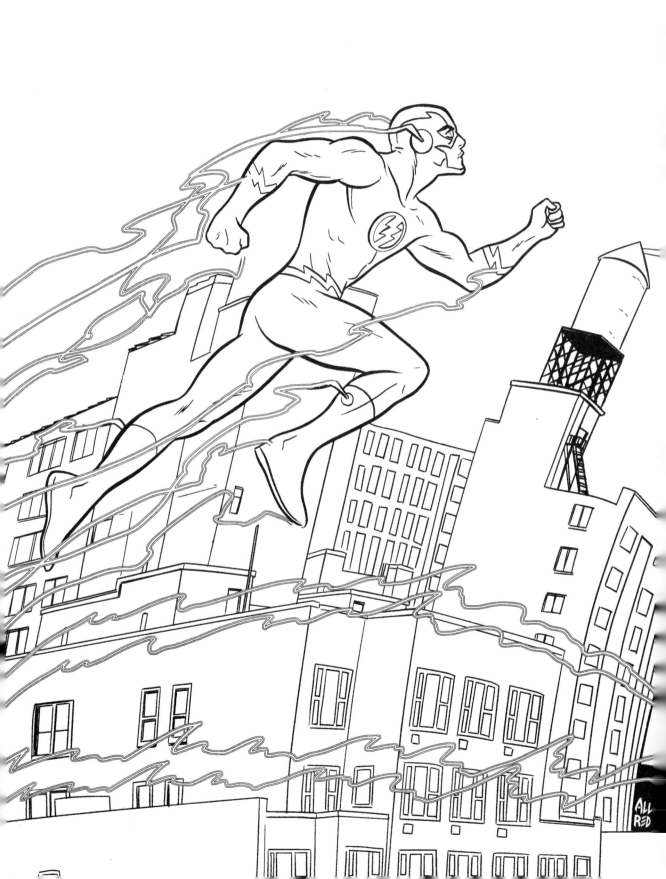

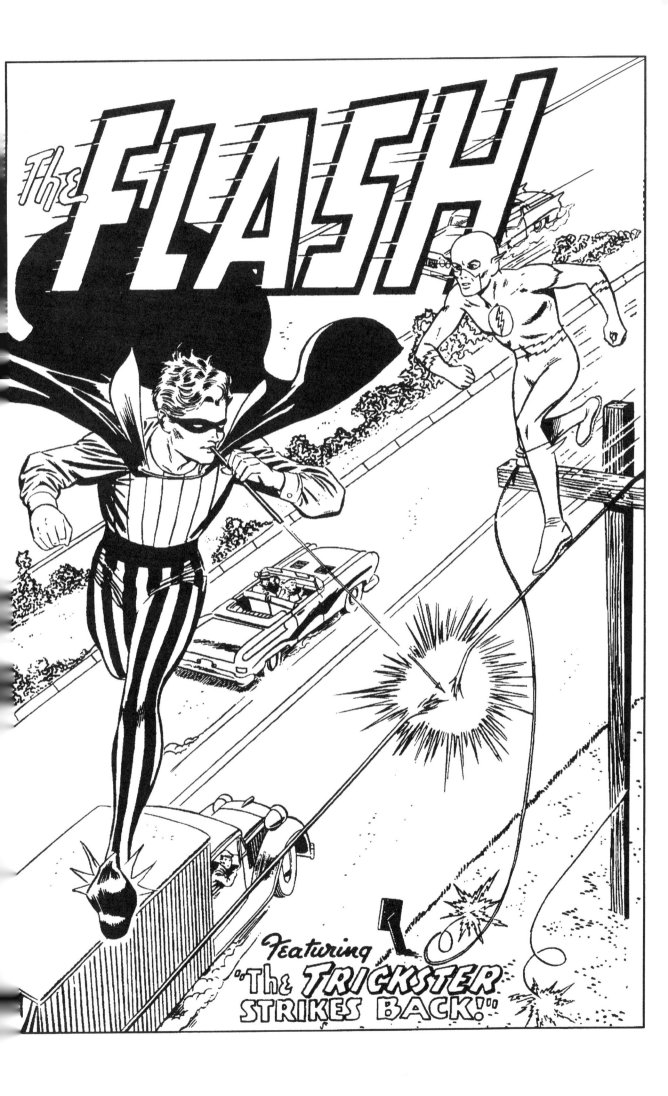

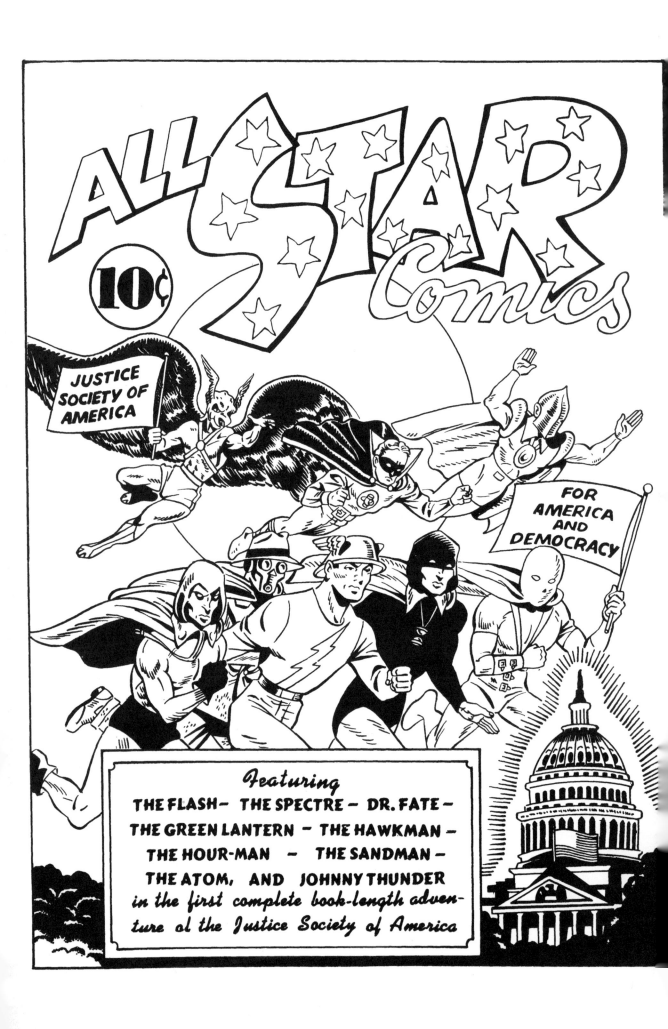

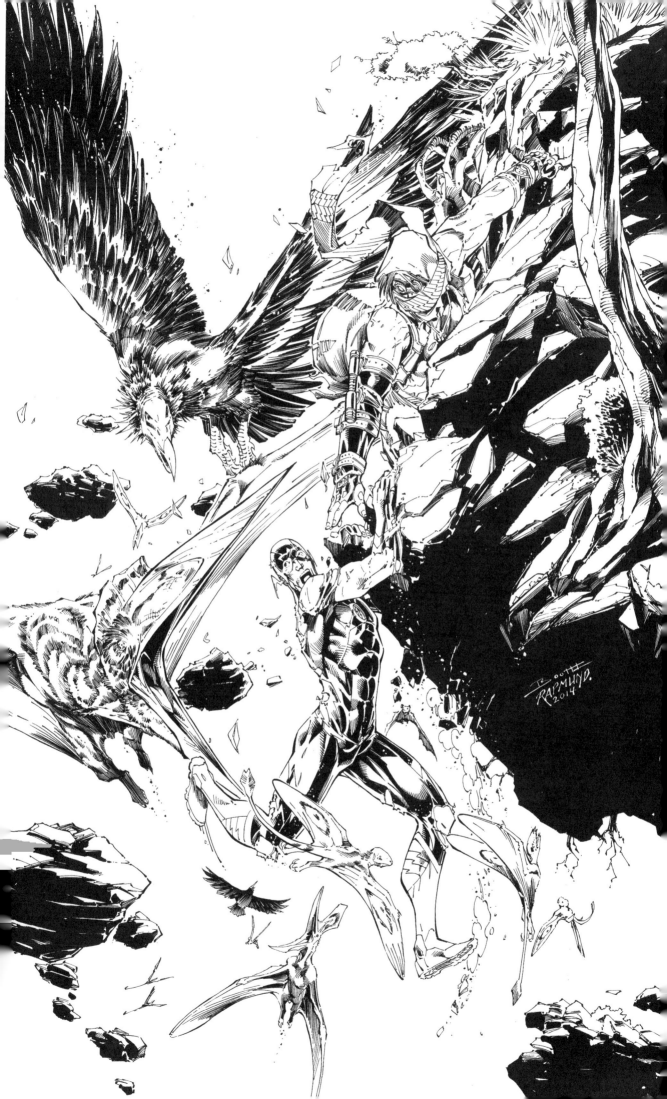

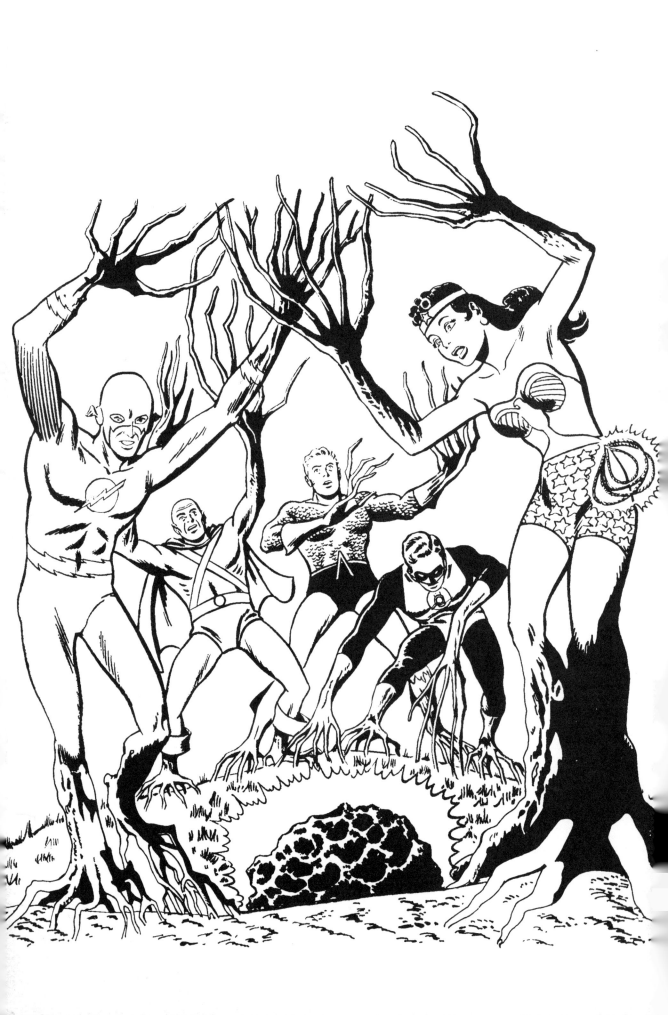

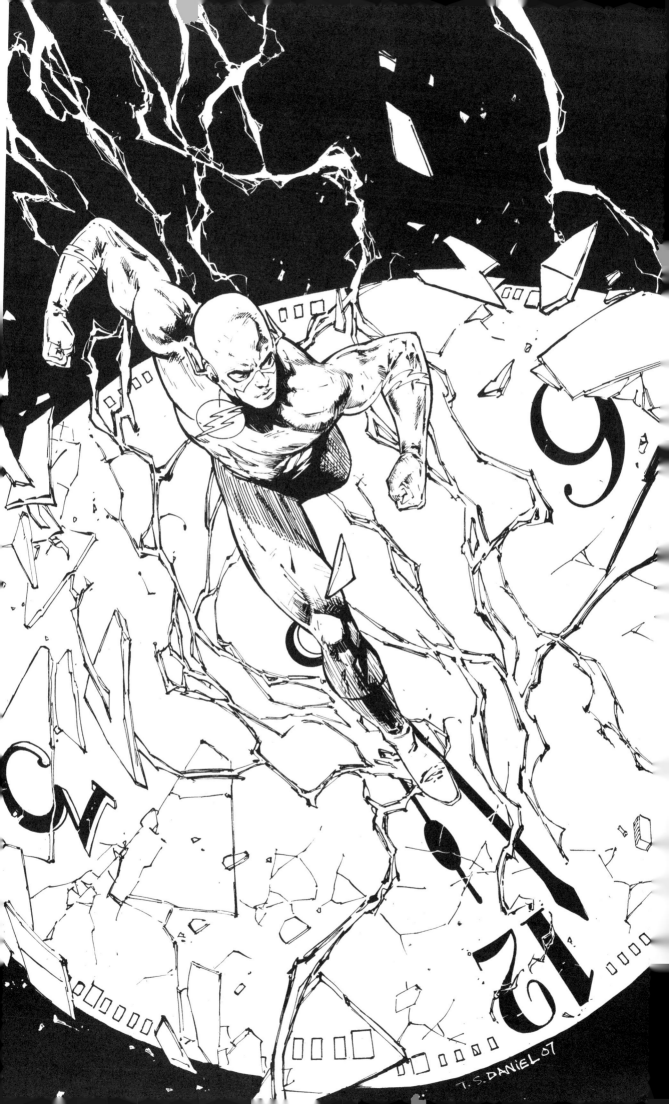

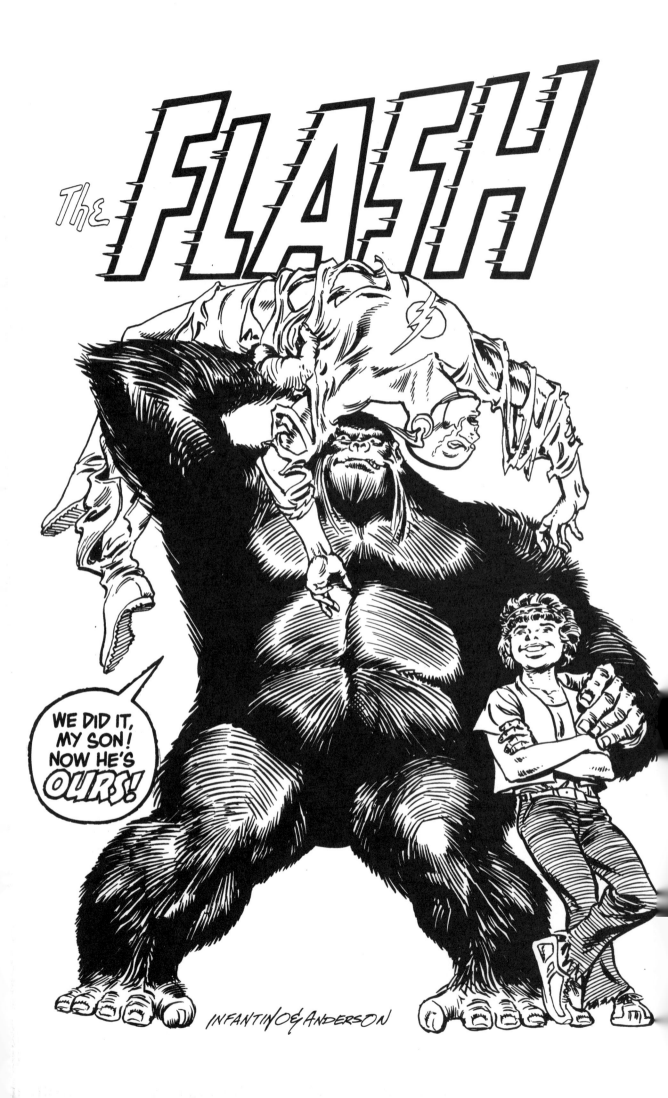

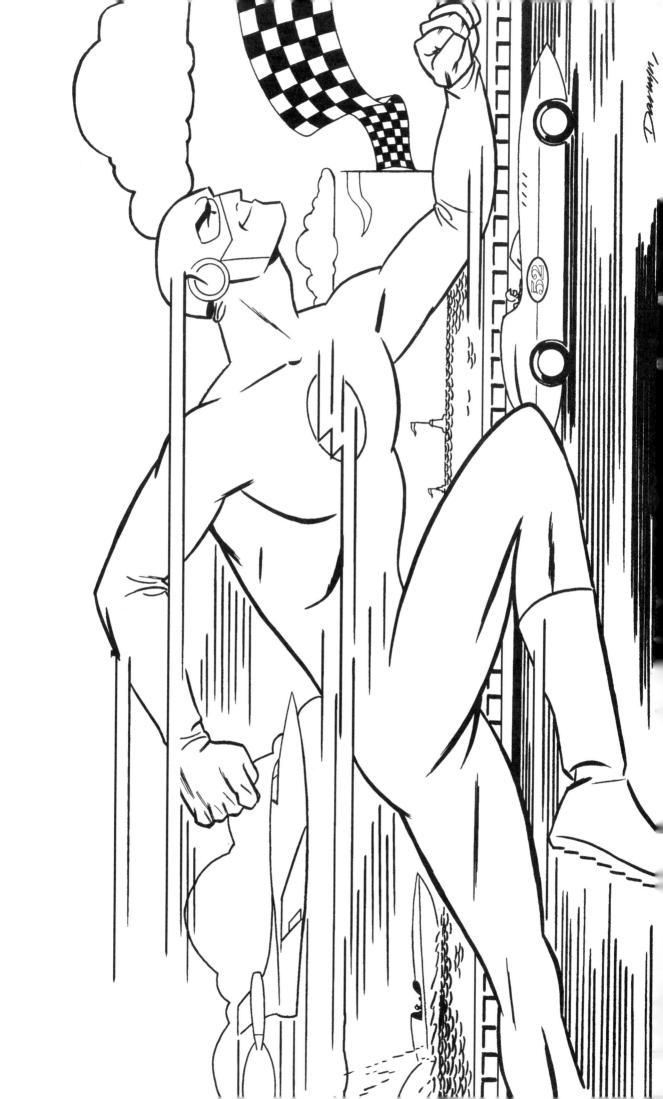

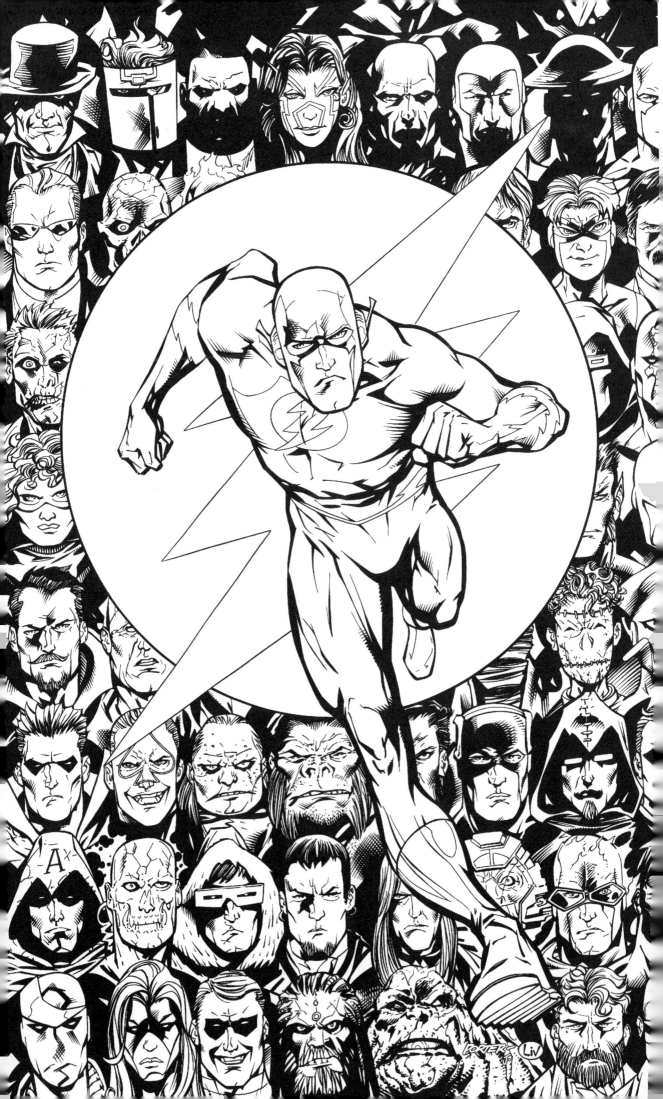

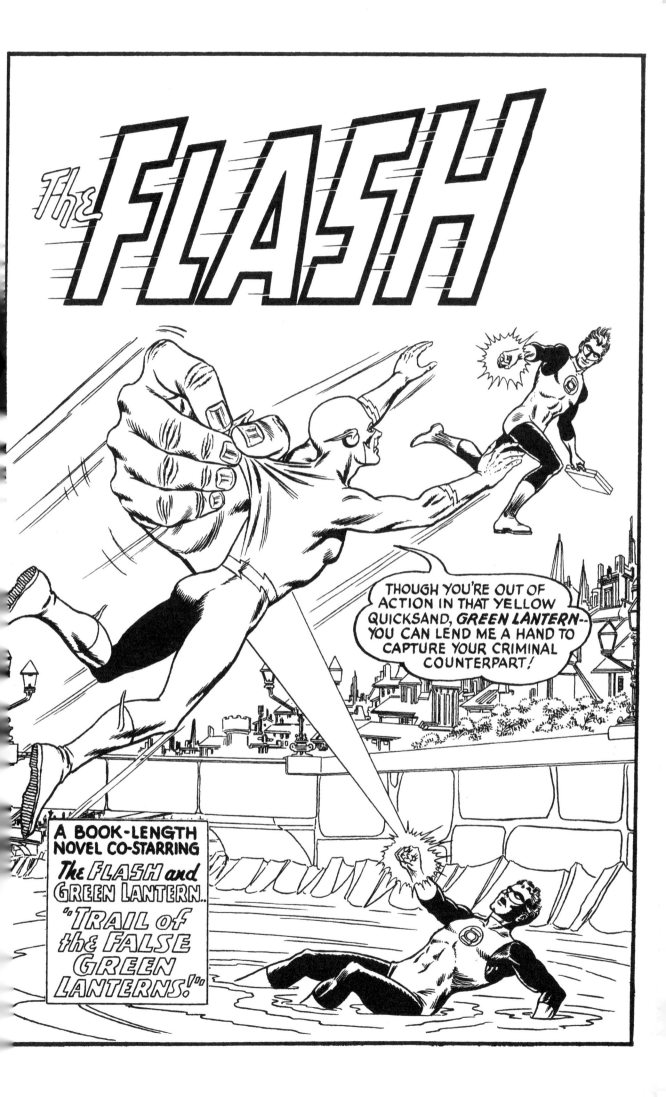

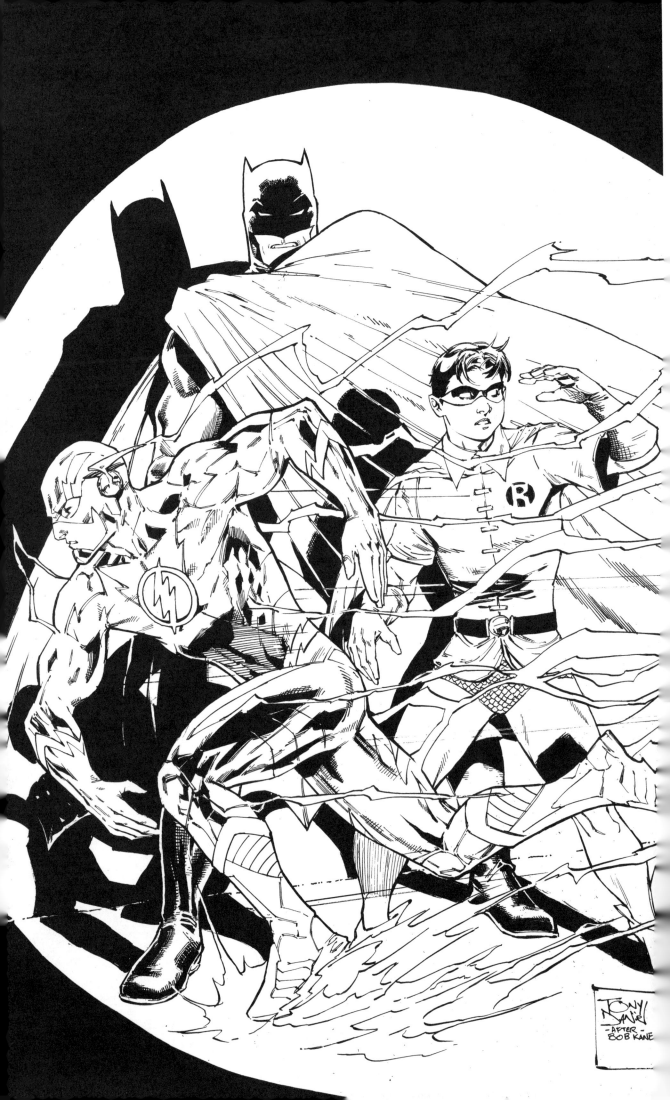

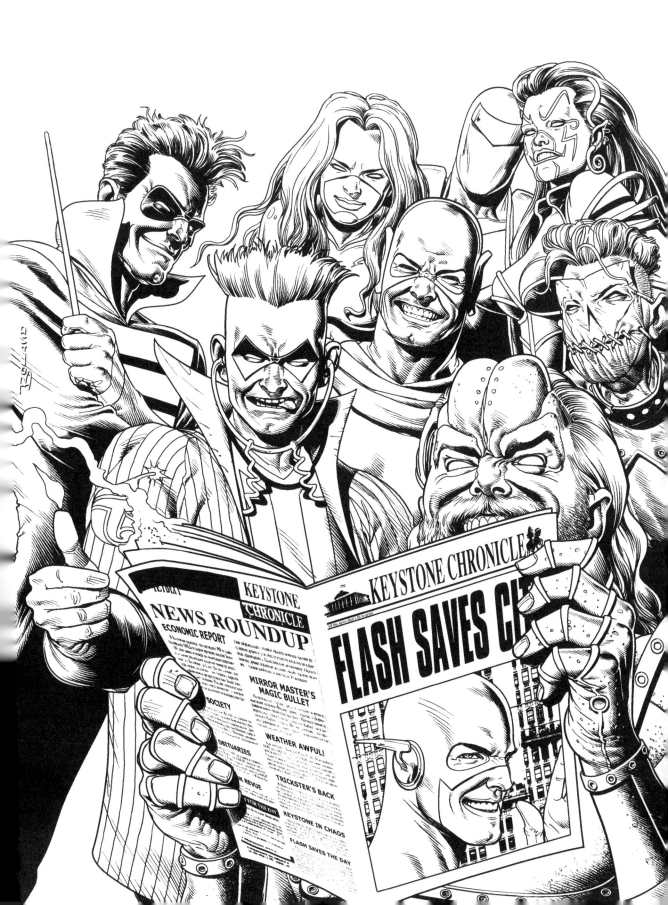

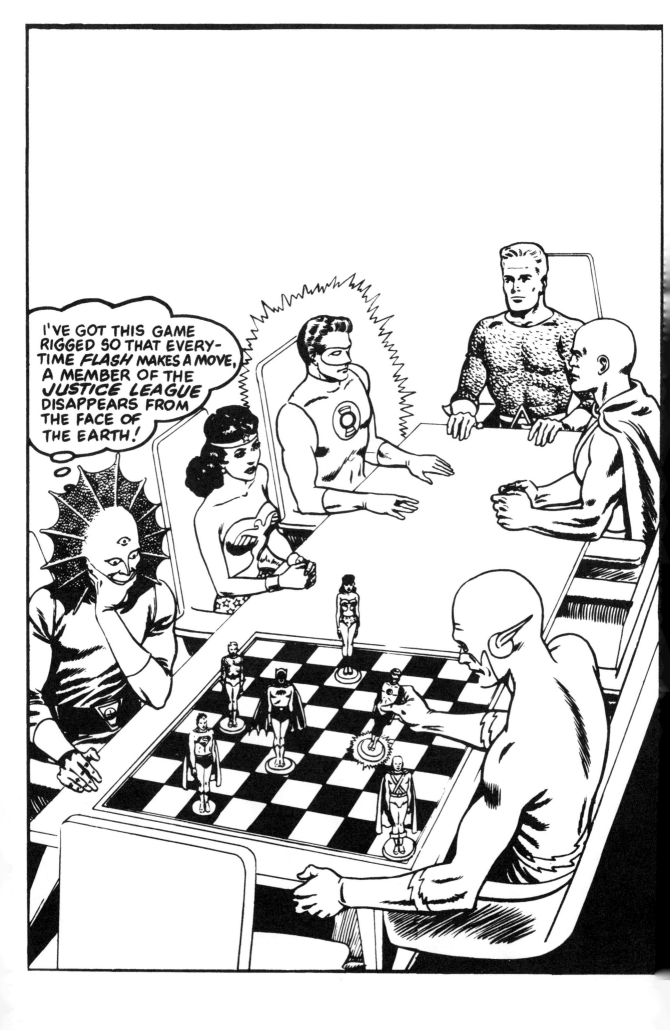

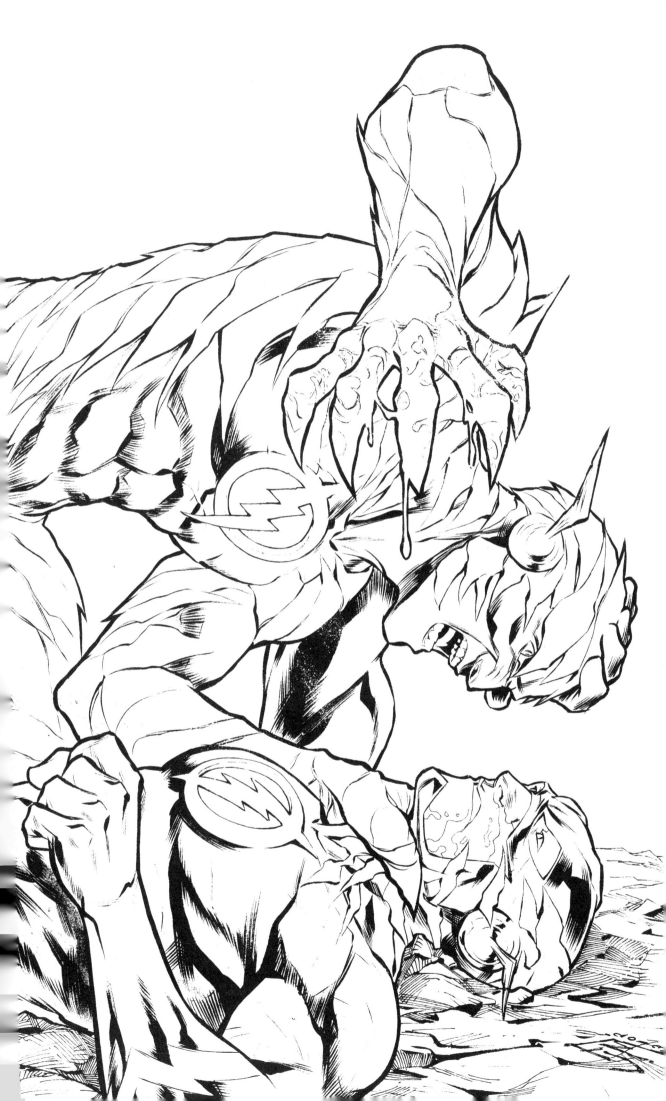

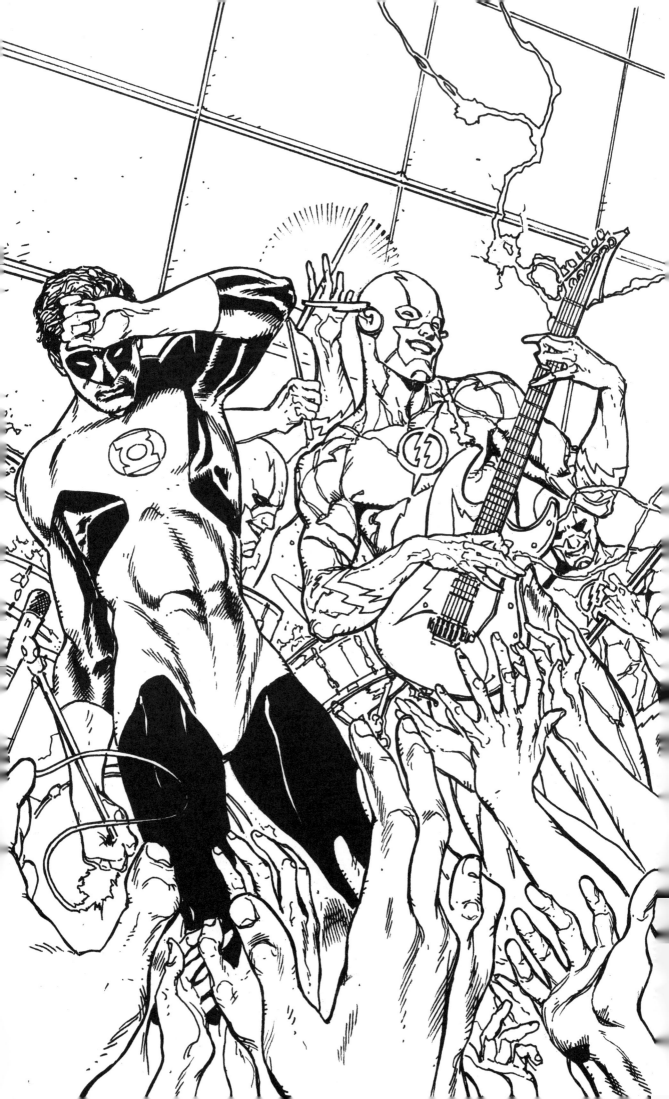

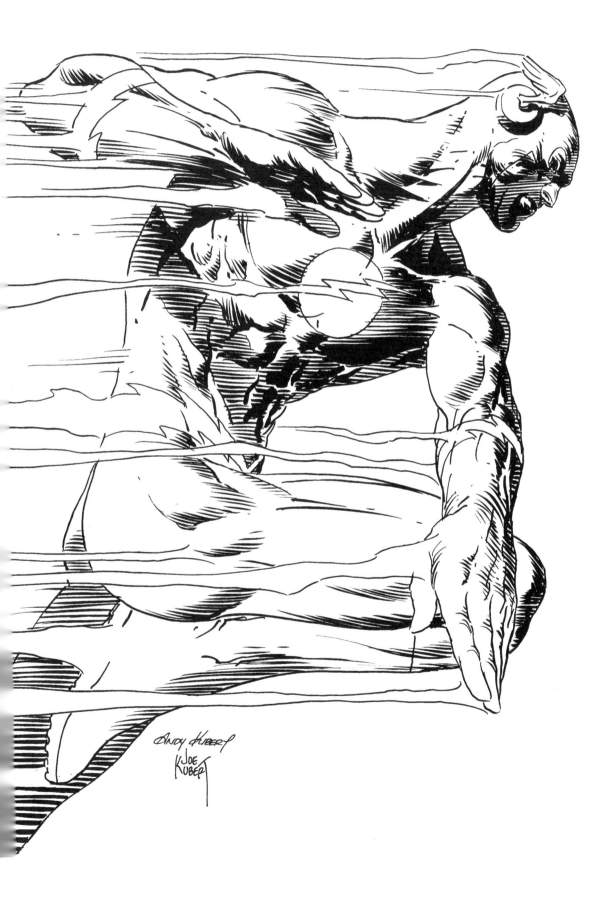

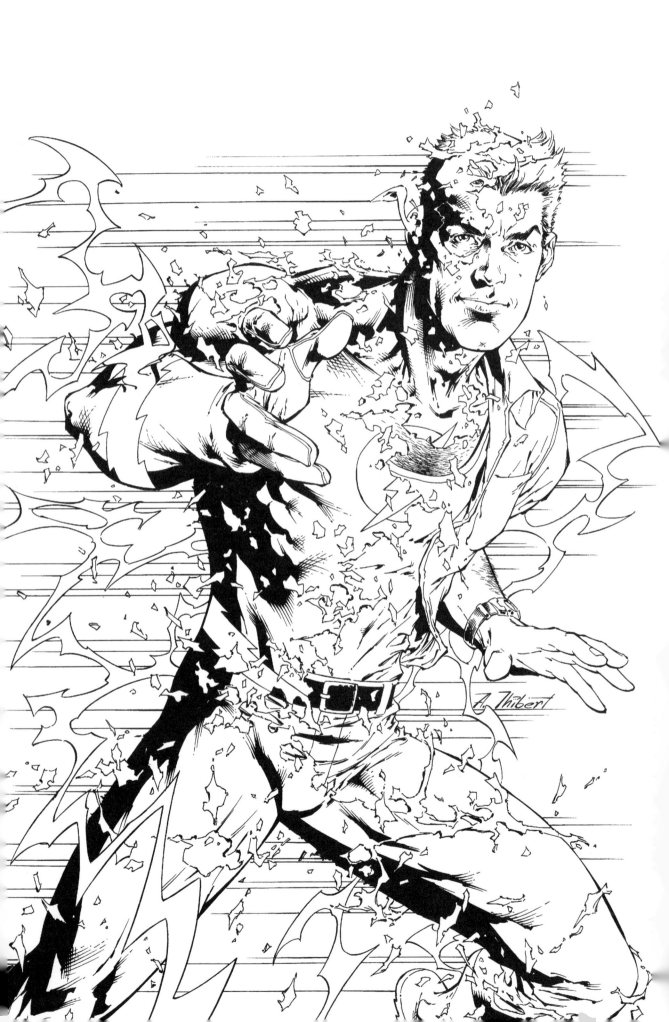

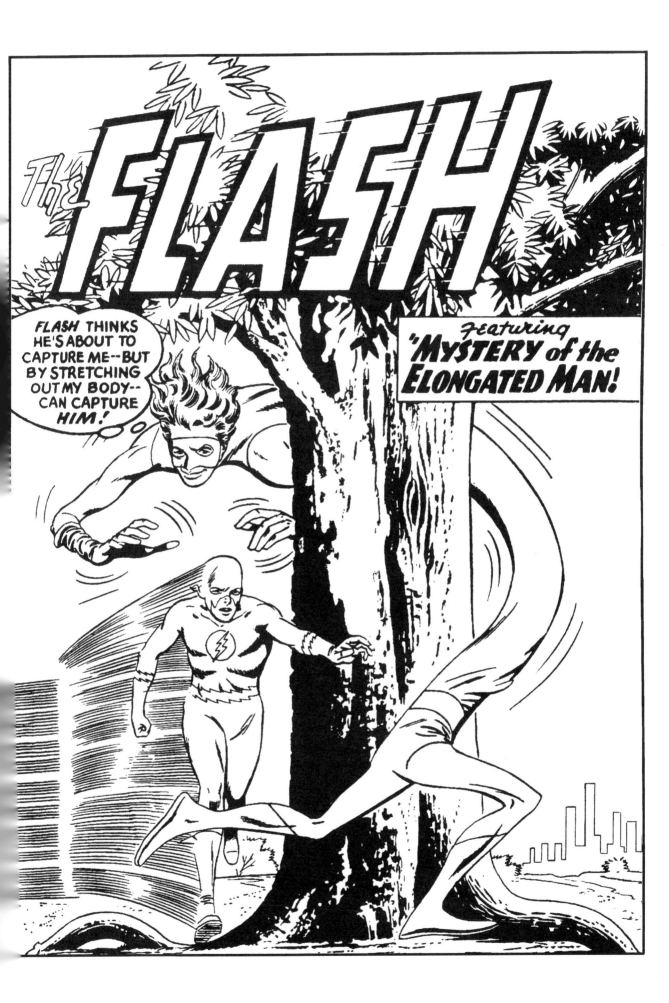

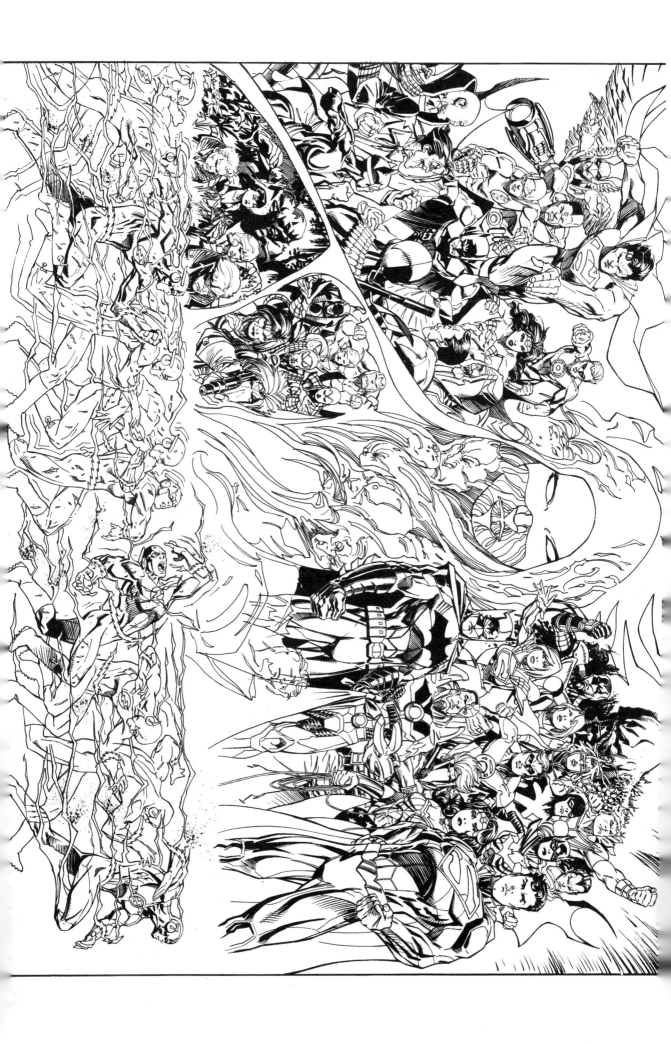

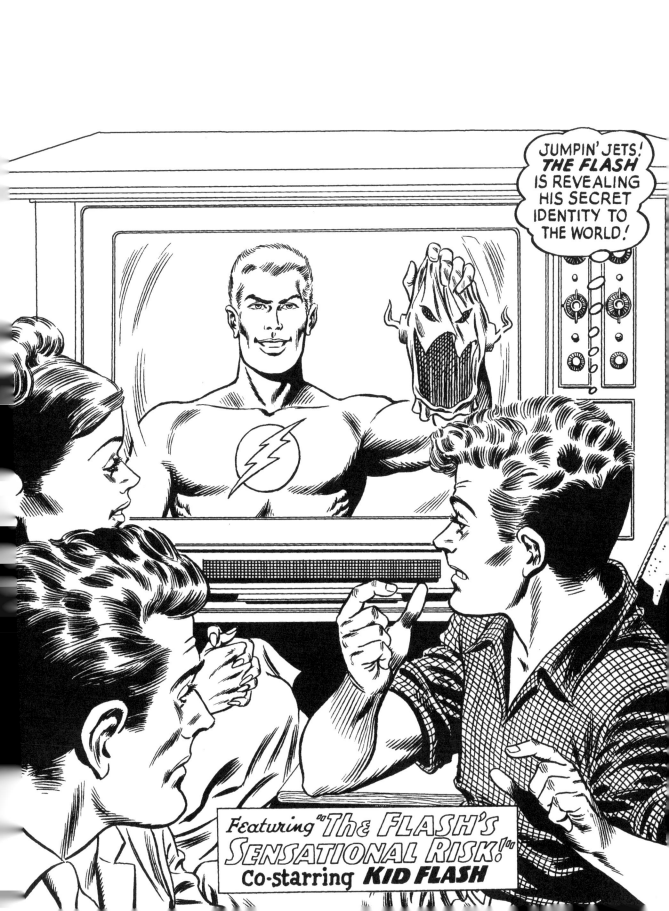

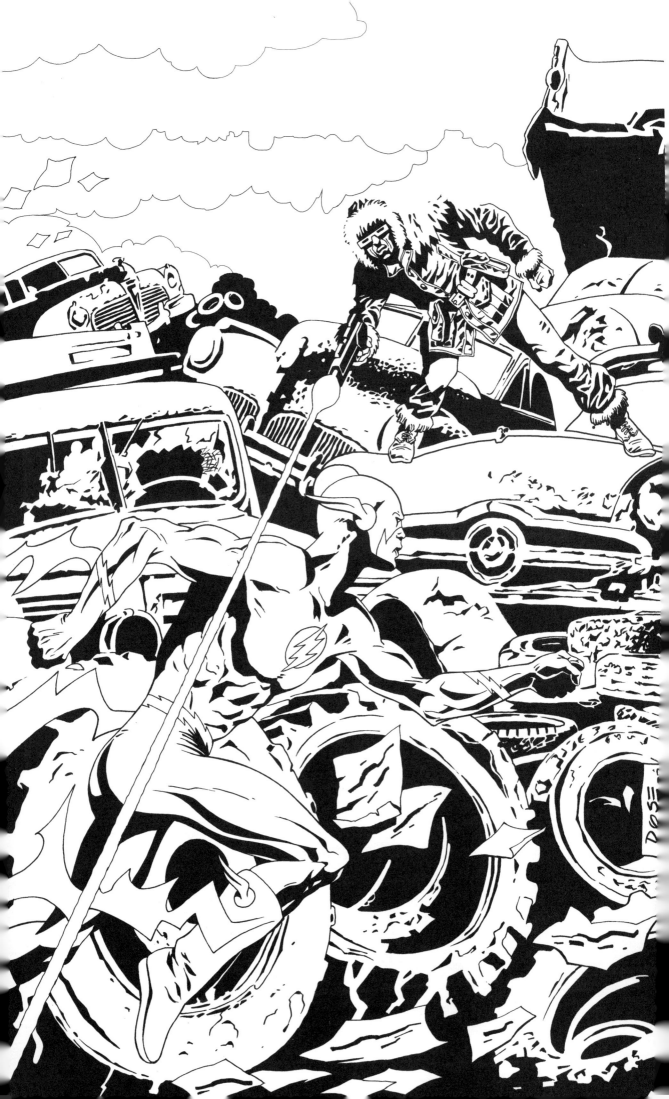

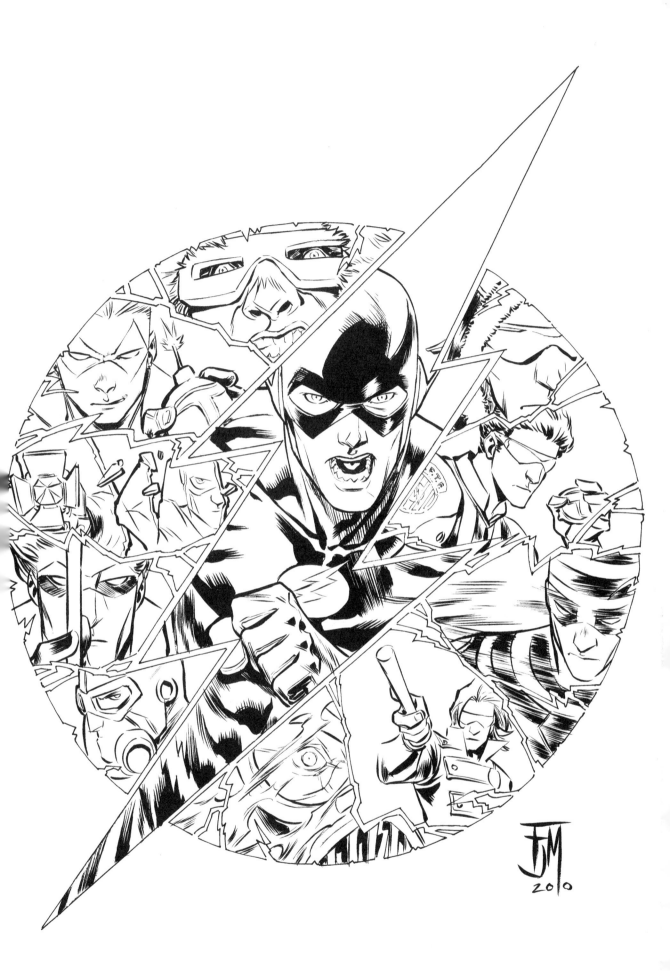

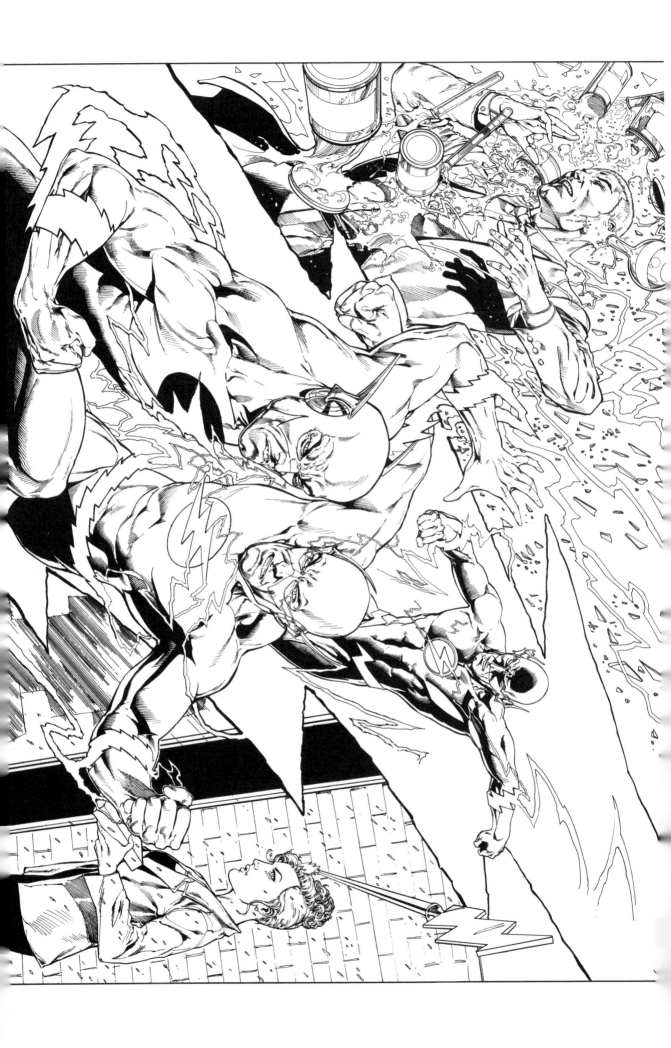

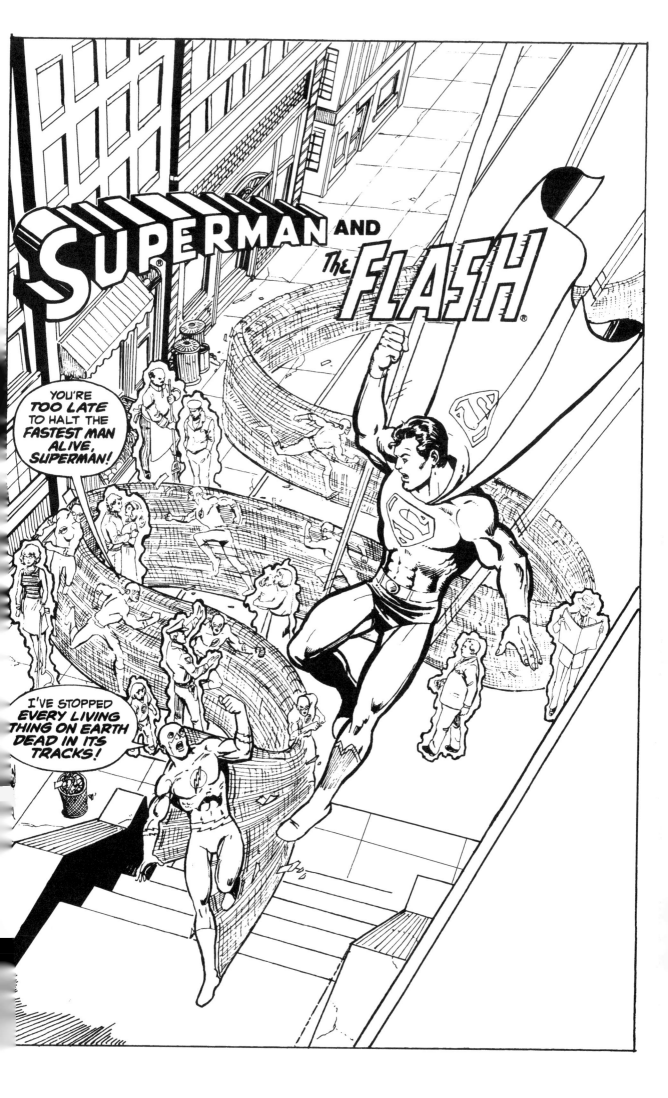

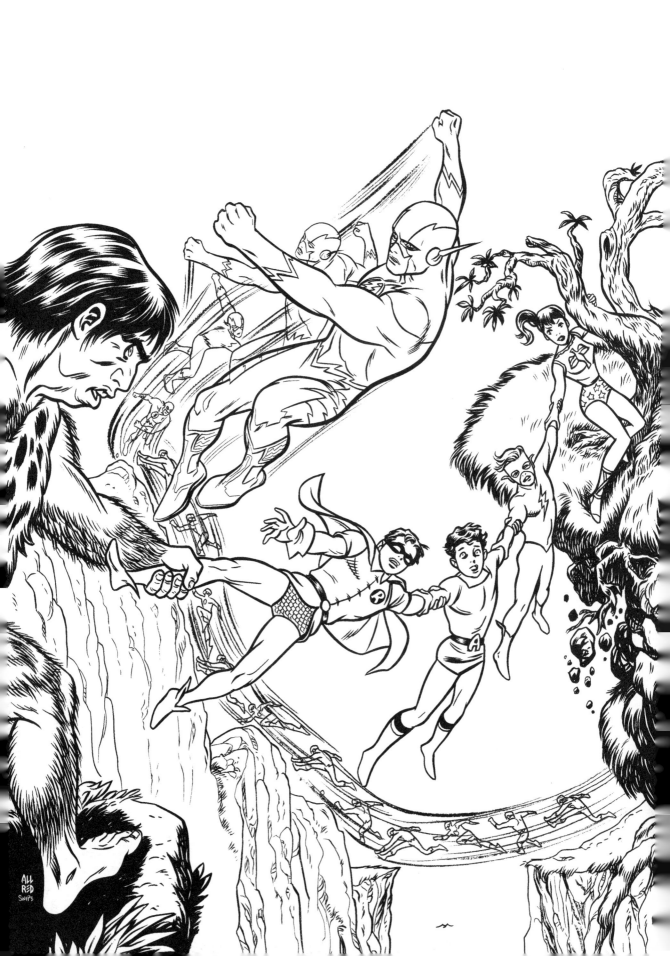

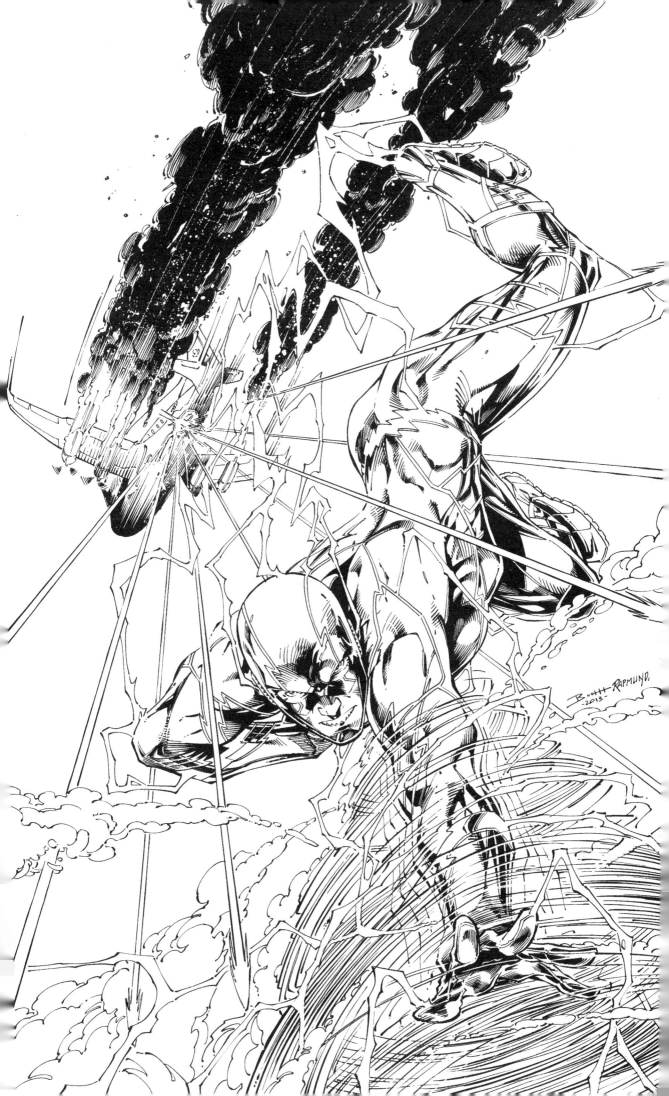

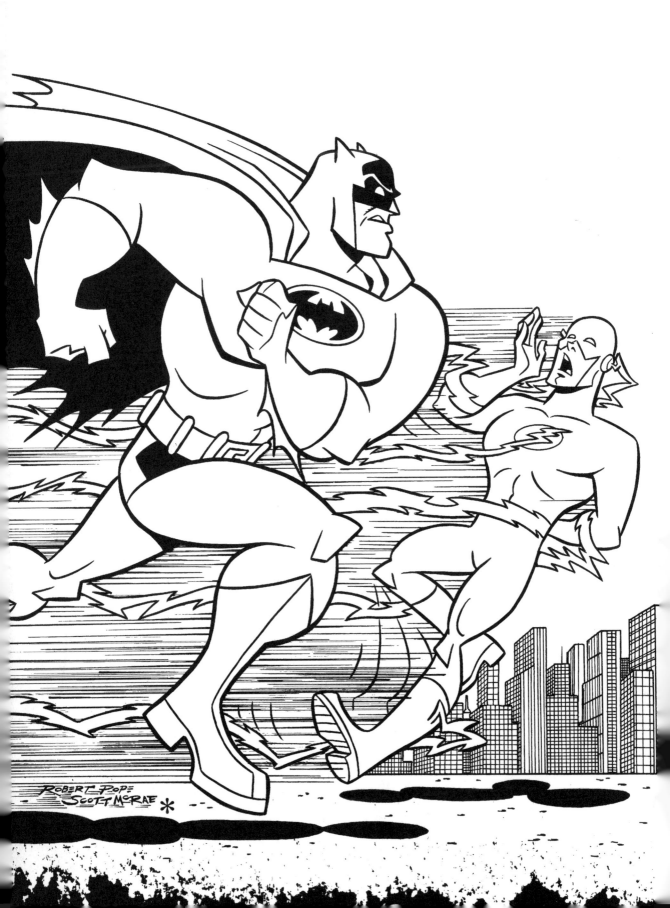

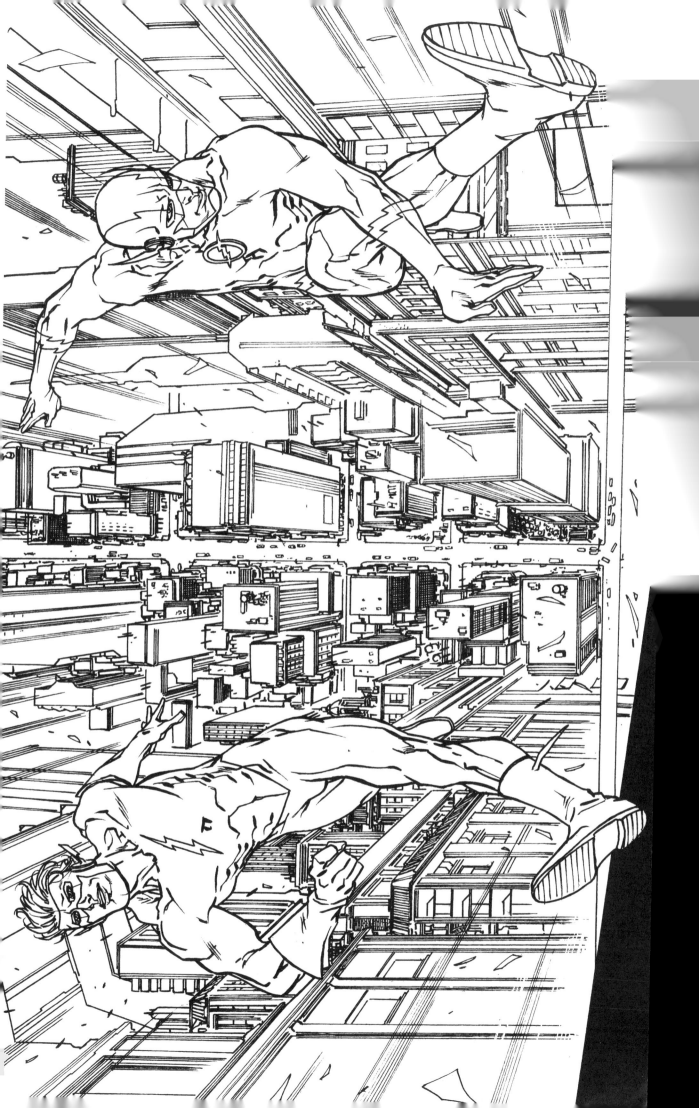

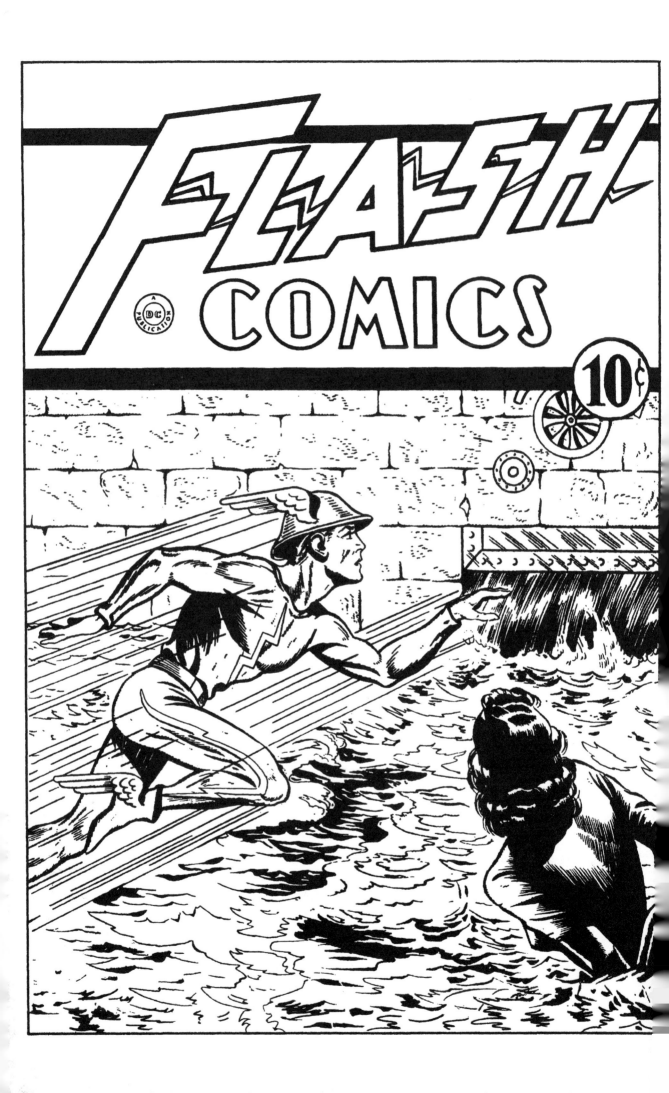

IN ORDER OF APPEARANCE

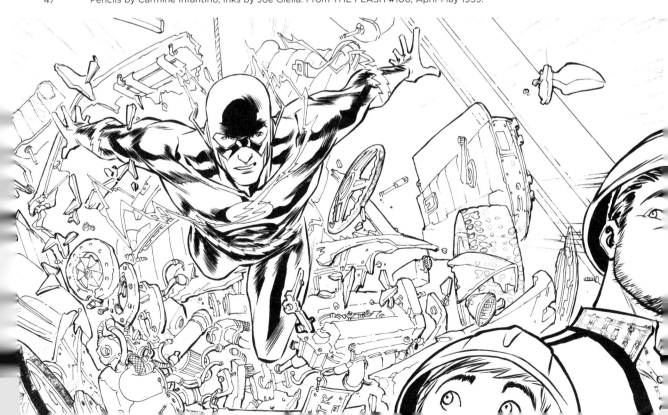

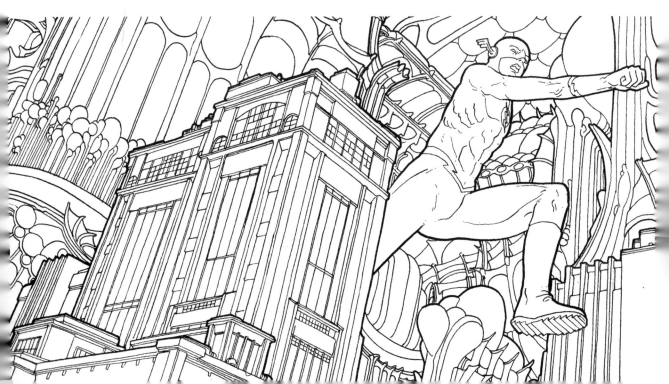